IMAGES
of America

BROADWAY

For Gilly,
Enjoy Broadway!

IMAGES
of America

BROADWAY

Michelle Young

ARCADIA
PUBLISHING

Published by Arcadia Publishing
Charleston, South Carolina

Printed in the United States of America

Library of Congress Control Number: 2014948879

For all general information, please contact Arcadia Publishing:
Telephone 843-853-2070
Fax 843-853-0044
E-mail sales@arcadiapublishing.com
For customer service and orders:
Toll-Free 1-888-313-2665

Visit us on the Internet at www.arcadiapublishing.com

To Augustin Pasquet, who inspires me to keep discovering every day, the community of explorers at Untapped Cities, and my parents and grandparents, who have supported all of my wide-ranging endeavors.

CONTENTS

ACKNOWLEDGMENTS

The historic images from this book are predominately sourced from the Library of Congress Prints and Photographs Division (LOC) and the New York Public Library (NYPL). Thank you to Gregoire Alessandrini and Michael Minn for allowing me to publish their photographs of New York City in the 1990s. Photographs from the present-day are taken by Augustin Pasquet, Bhushan Mondkar, Jane Hu, Julia Vitullo-Martin, and myself.

A special thank you to *Untapped Cities* editors Benjamin Waldman and Laura Itzkowitz for their patient reads of this manuscript and my editor at Arcadia, Sharon McAllister and Ryan Easterling.

INTRODUCTION

The history of Broadway, from its origins as a Native American trail to its iconic status in global culture today, tells the story of the city of New York as it grew from a Dutch colony into a world-class metropolis. Broadway has been the site of many firsts and many superlatives: the first subway line in the city, the tallest buildings, and one of the longest streets in the world. Broadway begins along the winding streets of the original settlements amidst the skyscrapers of the financial district. It then enters the environs of New York City Hall, where the fashionable and the political once converged and where the city's newspaper industry had its start.

Broadway runs through the vastly transformed neighborhoods of SoHo and Greenwich Village before passing through some of the city's most famous plazas, including Union Square, Madison Square, Herald Square, Times Square, and Columbus Circle. As the street enters Upper Manhattan, it bypasses storied institutions like Lincoln Center, Columbia University and City College, as well as some of the city's great parks, such as Fort Tryon Park and Van Cortlandt Park.

As a thoroughfare, Broadway can be traced back to the Native Americans' Wickquasgeck Trail, which was carved through the bush of Mannahatta. It became one of the two main streets formed during the settlement of the Dutch West India Company. Known at the time as de Heere Straat ("Gentlemen's Street"), Broadway originated at Fort Amsterdam and followed a natural ridge of land that led northwards through the fields and farms of New Amsterdam. De Heere Straat extended to a fortification along present-day Wall Street that protected the Dutch colonists from English encroachment. First constructed as a simple picket fence in 1653, the wall developed into a 12-foot bulwark. There were only two entry gates, with one situated on de Heere Straat opposite Trinity Church.

Under the English, New Amsterdam was renamed New York, after the Duke of York, brother to King Charles II. Fort Amsterdam, located at the foot of Broadway, became Fort James. The fort and environs became the center of political and social life in the new colony, and it is not surprising that the first meeting to protest the 1765 Stamp Act took place at Burn's Coffee House on Broadway, opposite Bowling Green.

Bowling Green, where Broadway begins, has had many lives, even prior to its designation as the first public park in New York City. It was a parade ground, a cattle market, a public gathering place, and a political meeting point. Today, it can be hard to imagine a singular space used for both bonfires and for the signing of war treaties, but such was this public space at the start of Broadway.

The city's first government institutions were also located at Bowling Green following the Revolutionary War, but as the city moved northwards, so did the various political, commercial, and cultural institutions. Even the city's pleasure gardens—19th-century entertainment venues—would move to wherever the new outer boundary of settlement would be at the time.

Throughout history, Broadway has been at the forefront of the city's urban developments. Downtown, the street was a testing ground for the soaring skyscrapers. By New York City Hall,

the architecture reflected both the aspiration and corruption of a young nation defining its legacy. The angle of Broadway against the gridiron streets enabled the formation of public spaces that served as meeting grounds for the country's social movements. The Interborough Rapid Transit, the city's first subway line, opened in 1904 and ran along Broadway, north of Forty-second Street, solidifying the importance of the street in future development.

While tracing Broadway through the bounty of historical images, I was struck not only by how much has changed and what has been lost, but also the remnants of the past that still persist. From entire buildings, landmarked and preserved, to forgotten pieces of former estates, these relics of history sit side-by-side with construction from every era of New York City's history. All are a testament to the city's ability to reinvent itself, to bear witness to humanity's achievements, and to overcome great tragedy.

The hustle and bustle of New York City's "Great White Way" continues to this day, and new developments along the historic street are unsurprisingly contentious. From Columbia University's expansion into Manhattanville to the permanent pedestrianization of Times Square, New Yorkers remain in the age-old contradiction of holding onto the past while ever pushing forward.

Other new exciting projects have come from collaborative community effort following the devastation from Hurricane Sandy. The BIG U by Bjarke Ingels Group, part of the Rebuild by Design competition, proposes a protective system around Manhattan that may radically change existing public space in Battery Park and other coastal areas to better protect downtown Manhattan from future storms. Downtown will also be getting new transit stations, servicing a revitalizing neighborhood that is still in the process of rebuilding after the September 11th attacks. Streetscape improvements and bicycle lanes have reclaimed part of the roadways once the prerogative of the automobile, moving New York City closer to its pedestrian roots.

Any compilation of photographs encompassing such a famous topic necessitates a conscious editing of material. Working with historical sources also means that bias has already been incorporated: What earlier photographers chose to document and what they left out leave gaps in the record that cannot be rectified today. Yet their concerted choices give weight to the importance of certain moments in history and the consequence of the buildings that awed their aesthetic sensibilities. In an age of obsessive documentation, there is hope that future generations may have a greater awareness of what came before.

One

NATIVE AMERICAN TRAIL
TO REVOLUTIONARY WAR

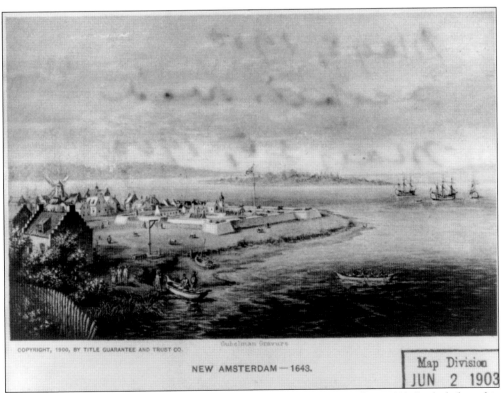

COPYRIGHT, 1900, BY TITLE GUARANTEE AND TRUST CO.

Gubelman Gravure

NEW AMSTERDAM — 1643.

Map Division
JUN 2 1903

Shown here is the Dutch colony of New Amsterdam as it appeared in 1643. Included in this painting are Fort Amsterdam and Noten Eylant (Nut Island), known as Governors Island today. Fort Amsterdam was located at the southern terminus of Broadway, where the Alexander Hamilton US Custom House is today. The coastline of downtown Manhattan was also much narrower then, with several periods of landfill and extensions over the centuries. (LOC.)

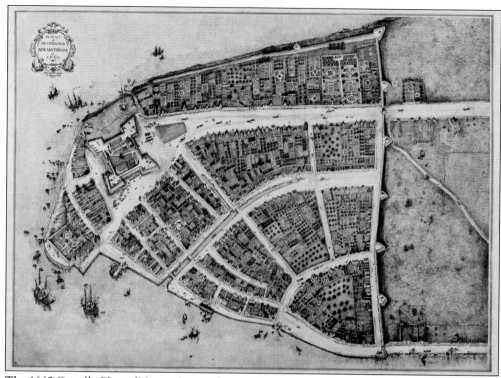

The 1660 Castello Plan of Nieuw Amsterdam, made by surveyor Jacques Cortelyou, is the earliest street plan of the Dutch settlement. The wide street is de Heere Straat, now Broadway. The Dutch widened the Wickquasgeck Trail as it approached Fort Amsterdam, turning it into a main artery. Along Broadway, individual houses fronted the street with formal gardens behind. Interspersed along the road were also warehouses and outhouses. De Heere Straat intersects what is now Wall Street, with the land gate at de Heere Straat opening to the farmland beyond. The original map was sold to Cosimo III de' Medici, grand duke of Tuscany, around 1667. The map, which also contained information about land parcel ownership and tenancy, was rediscovered in 1900 at the Villa di Castello near Florence, where it gets its name. (Redraft of the Castello Plan of New Amsterdam by John Wolcott Adams and Isaac Newton Phelps Stokes, New York Historical Society Library Maps Collection, 1916.)

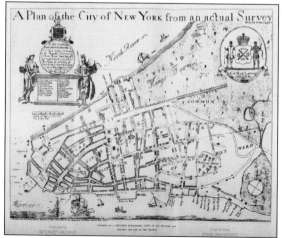

Known as the Bradford Map, this 1730 plan of New York by surveyor James Lyne is the first map of New York City printed within the municipality itself. Broadway was initially extended to connect the fort to the orchards of the Dutch East India Company. This map, along with contemporary accounts, suggests that Broadway was tree-lined and quite pleasant to walk through. (Map from *New York in 1731*.)

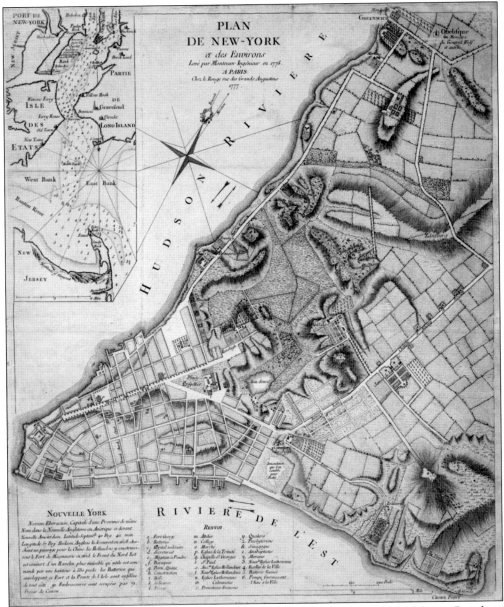

The Dutch street plan remained largely intact despite English takeover. In this 1775 map, Broadway has extended far past Wall Street to Ranelagh Gardens, a pleasure garden on Duane Street, just north of where the city settlements ended. Broadway at the time also took the form Broad Way, which the Dutch called Breede Weg. Labeled along Broadway are Trinity Church, a Lutheran church, a high school, and St. Paul's Chapel. The complex that is now City Hall Park contained a prison, barracks, and storage for gunpowder, and nearby was King's College, later Columbia College. The map also notes that during this time there was a 530-foot ravine, "more harmful than useful," around the fort, now named Fort George. Seventy-one canons surrounded the fort. ("Plan de New York" by Montresor, the Lionel Pincus, and Princess Firyal; courtesy of Map Division, NYPL.)

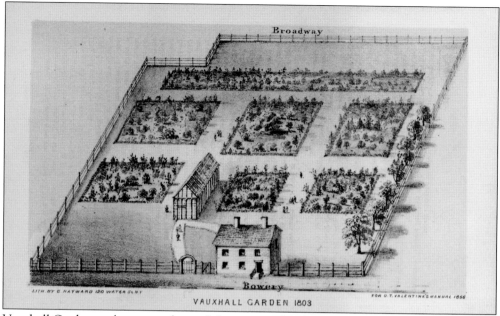

Vauxhall Garden, a pleasure garden and theater, was first located on what are now Warren and Chambers Streets in present-day Tribeca. As the city expanded northwards, so necessitated the move of the pleasure gardens. Vauxhall Garden first decamped to Broome Street between Broadway and the Bowery, then to Lafayette Street, and lastly to what is now Astor Place at the intersection of Broadway. (Mid-Manhattan Picture Collection, NYPL.)

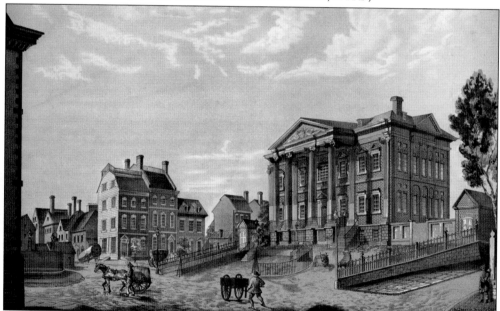

The Government House at the southern terminus of Broadway was designed for Pres. George Washington when Congress was located in New York City. In 1790, Philadelphia became the country's temporary capitol while Washington, DC, was being constructed. Washington never occupied this building, and it became the Governor's House for George Clinton and John Jay. It was the custom house until 1815, when it was demolished. (LOC.)

Two

ARTERY OF A
YOUNG NATION

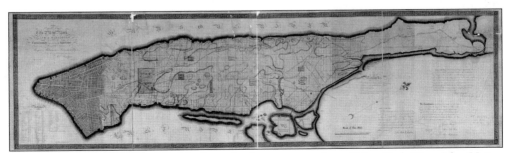

The Commissioners' Plan of 1811 laid out the future street plan of New York City. After Union Park, Broadway became the Bloomingdale Trail, which ascended the length of Manhattan. In the Commissioners' Plan, however, Broadway did not go beyond Twenty-third Street because its path would have interfered with the strict grid. Nonetheless, it was determined later that the thoroughfare was too important to be eliminated. (LOC.)

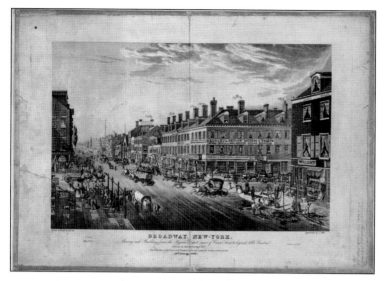

This 1836 illustration depicts Broadway from the Hygeian Depot at Canal Street to beyond Niblo's Garden on Prince Street. Within this busy, commercial artery existed a coffee house, a branch of the British College of Health, an upholstery shop, bookstores, a furniture warehouse, haberdasheries, and street vendors. (LOC.)

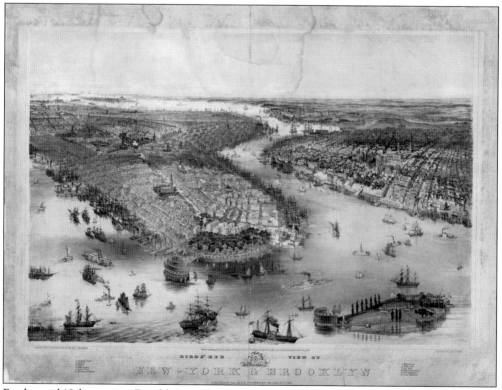

By the mid-19th century, Brooklyn was beginning to rival Manhattan, and by the 1860s, it was the third-largest city after New York City and Philadelphia. Still, the dominance of Manhattan's Broadway as a major thoroughfare is clearly visualized in this 1851 aerial map. While lower Manhattan is densely built at this time, urban development ended approximately where Madison Square Park is today. (Print by John Bachmann, LOC.)

Located at Broadway and Prince Street, Niblo's Garden was a fashionable and famous entertainment destination that opened in 1829 on the site of the Columbian Gardens. With a theater, saloon, and hotel, the facility had a capacity of 3,000. It has been said that the polka was introduced there in 1844. (LOC.)

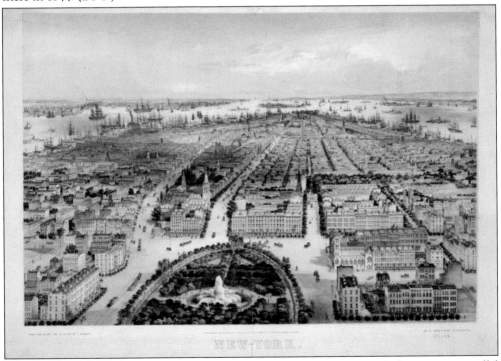

This 1849 bird's-eye view shows the continued importance of Broadway, with the Bowery a parallel thoroughfare. At the time, stately homes with first-floor balconies and front yards surrounded Union Park (now Union Square). (LOC.)

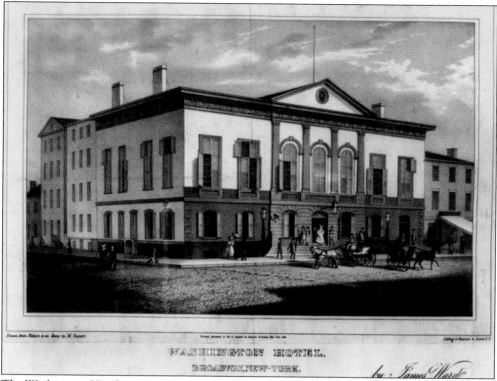

WASHINGTON HOTEL.
BROADWAY, NEW-YORK.

The Washington Hotel at 1 Broadway was one of the many taverns that dotted New York and was the headquarters of George Washington during the American Revolution. In the 18th century, the building was the home of Capt. Archibald Kennedy, a Scottish peer and later the 11th earl of Cassilis. It turned into the Washington Hotel and was rebuilt as the Washington Building in 1884. (LOC.)

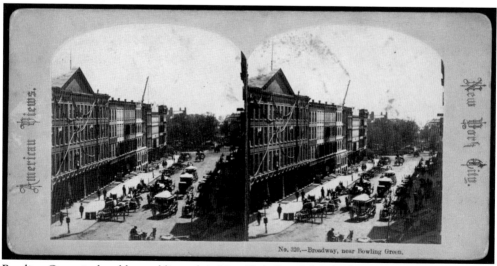

Bowling Green is the oldest public park in New York City. It has had many lives, first as a parade ground and cattle market when it was situated opposite Fort Amsterdam. After the American Revolution, it became a mostly private park for the inhabitants of the townhouses built around it and was turned into a public park around 1850. (LOC.)

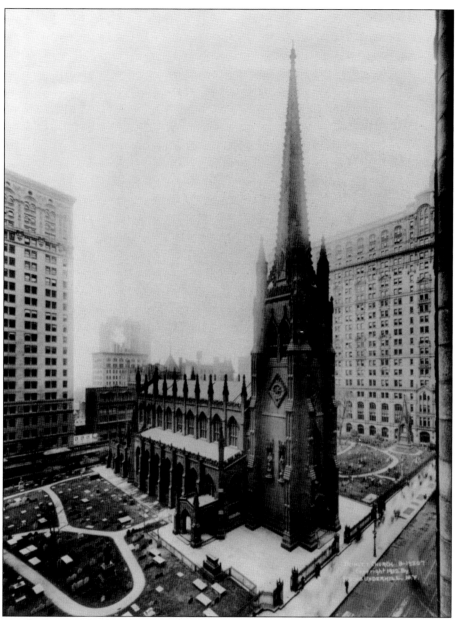

The Anglican Trinity Church was formed in 1697 by decree of royal charter from King William III. The current structure, the third to sit on this site on Broadway, was completed in 1846 and designed by Richard Upjohn, cofounder of the American Institute of Architects. The original church was lost in a fire in 1776, and the second was demolished because of structural problems. The first campus of Columbia University, chartered by George II as King's College in 1754, was located in a vestry hall in Trinity Church. In 1760, the college moved to Murray Street between present-day Church Street and West Broadway. In 1785, after the American Revolution, the school was rechartered as Columbia College. Trinity Church also founded a school for free blacks in 1700. Trinity Church gave two-thirds of the 215 acres bestowed by Queen Anne to the city but still manages the rest of the land through Trinity Real Estate. The 14 remaining acres have a value of over $2 billion, as reported by the *New York Times* in 2013. (Irving Underhill, LOC.)

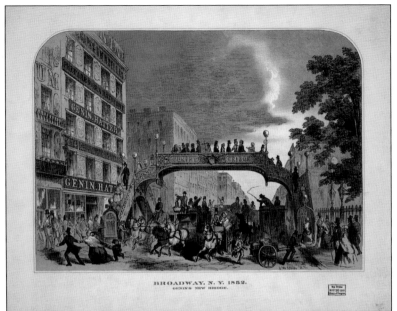

BROADWAY, N. Y. 1852.
GENIN'S NEW BRIDGE.

In 1852, a cast-iron footbridge was built across Broadway at Fulton Street to encourage pedestrians to cross over the crowded and busy street. Built at the urging of Broadway merchants, particularly a hatter named Genin, it was generally disliked and torn down in 1868. (LOC.)

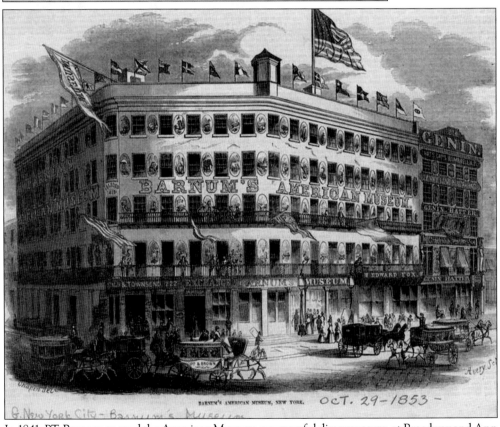

BARNUM'S AMERICAN MUSEUM, NEW YORK. OCT. 29-1853-

In 1841, P.T. Barnum opened the American Museum, a successful dime museum, at Broadway and Ann Street across from Astor House. The museum was destroyed by fire in 1865, whereupon it moved to a new location on Broadway and Spring Street. (NYPL, Mid-Manhattan Picture Collection.)

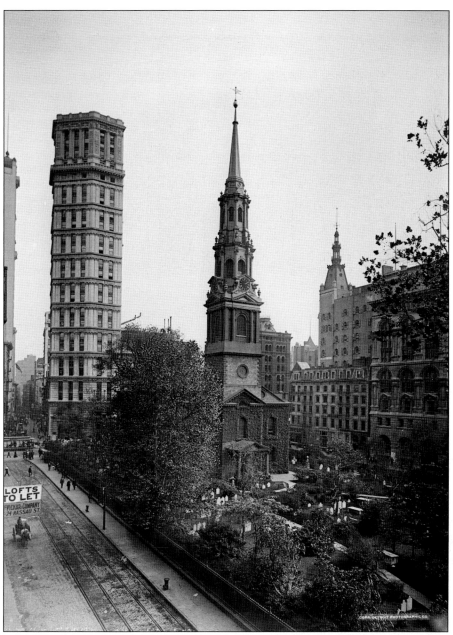

St. Paul's Chapel is the last of the city's colonial churches and is the oldest public building that has been continuously used. The chapel was completed in 1766, intended as a parish of Trinity Church for Anglicans who lived farther than convenient walking distance to Trinity Church. It survived the Great New York City Fire of 1776, and the tower and steeple were completed in 1796. George Washington had his own pew inside, as did Gov. George Clinton. St. Paul's Chapel, along with Trinity Church, served as a place of refuge from the 2001 attacks on the World Trade Center. St. Paul's functioned as the main center for the recovery operations. An ancient sycamore tree at St. Paul's was uprooted and later transformed by artist Steve Tobin into a bronze memorial sculpture, now located in front of Trinity Church. In the background of this photograph is the St. Paul Building, constructed in 1899 and demolished in 1958. (Detroit Publishing Co., LOC.)

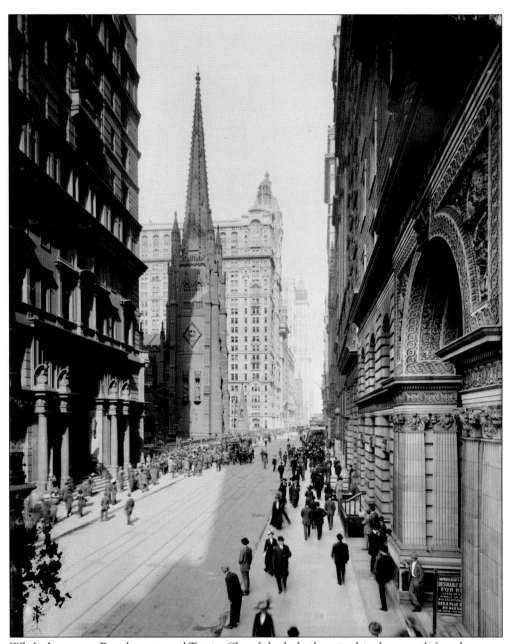

While downtown Broadway around Trinity Church looks built up in this photograph from between 1908 and 1913, many of the structures depicted would be demolished and replaced later. The building immediately to the right with the ornate archway would become 1 Wall Street by 1931. In the 1960s, more of the skyscrapers would be replaced, with an open space left for Zucotti Park along Broadway. (Detroit Publishing Co., LOC.)

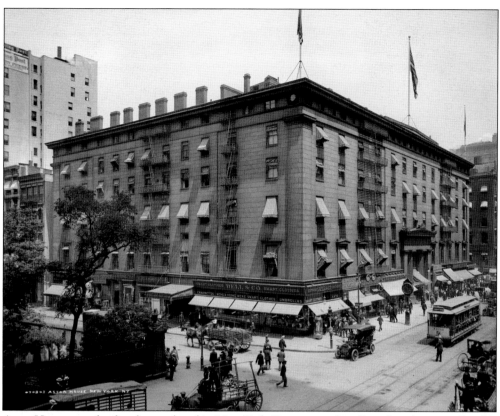

Astor House was the first luxury hotel in New York City, situated on Broadway between Barclay and Vesey Streets across from New York City Hall. It had running water before the Croton Aqueduct was completed in 1842. Its distinguished guests included Abraham Lincoln, who gave a speech there before his presidential election. In 1913, the hotel was demolished in phases to accommodate the construction of the subway. (Detroit Publishing Co., LOC.)

The French Second Empire–style post office in City Hall Park was almost universally hated and known as "Mullett's Monstrosity," after the architect. In 1869, when it was constructed, it was the largest post office in the world. It was also disliked because it took up precious open space in an already small park. It was proposed for demolition in the 1920s but survived until 1939. (LOC.)

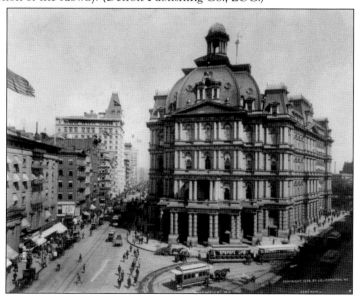

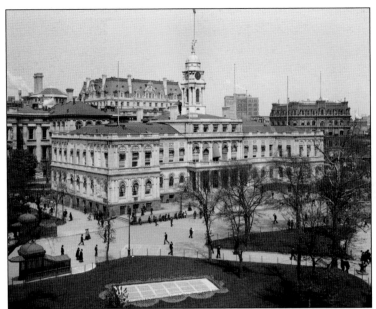

Construction on New York City Hall started in 1805, and the city council began to use the building in 1811. The government building, designed by James McComb Jr. and Joseph François Magin, has a marble exterior. The arrival of New York City Hall gave the surrounding area a chic reputation. It remains one of the oldest continuously used city halls in the nation. (Detroit Publishing Co., LOC.)

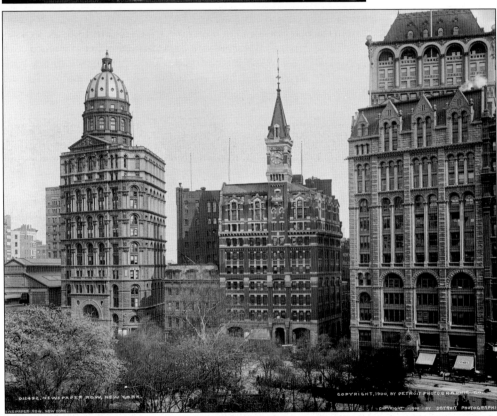

In the 19th century, Park Row, which began at Broadway, was also known as Newspaper Row, due to the concentration of daily newspapers that were headquartered there, including the *New York Times*, *New-York Tribune*, and *New York World*. The New York World Building, at left, was the tallest in the world from 1890 to 1894. (Detroit Publishing Co., LOC.)

The city's newspapers were distributed primarily by newsies—poor or homeless city children—who purchased the newspapers from the publishers and sold them on the streets. In 1899, the newsies staged a boycott against Joseph Pulitzer and William Randolph Hearst. Hundreds marched onto the Brooklyn Bridge, stopping traffic for hours. In the end, the publishers agreed to buy back any unsold papers. In the above photograph, the newsies are in front of the *New-York Tribune* building on Park Row. In the photograph below, the newsies are joined by nine-year-old newsgirl Mary Machalde. (Both, Lewis Wickes Hine, LOC.)

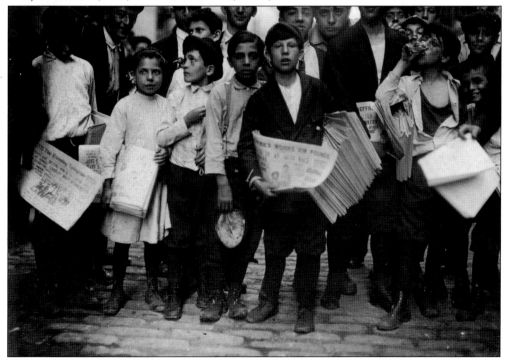

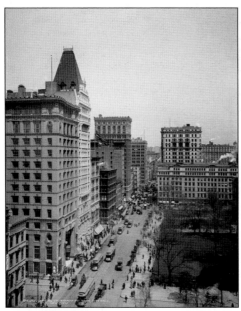

This view of Broadway looking north alongside City Hall Park shows two historically mismatched structures, the Postal Telegraph Building at 253 Broadway (at left) and the Home Life Building (the tallest in the photograph) next door at 256 Broadway. The plots of land were purchased in the same year, and the respective buildings were both finished in August 1894. They were joined together as one building after World War II. (LOC.)

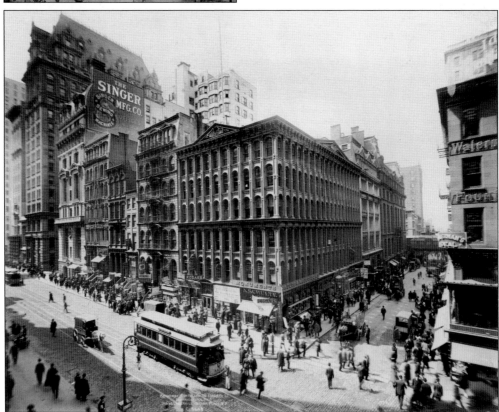

Shown here is a busy Broadway, filled with commerce from Cortlandt Street to Liberty Street. The signage shows a variety of shops that sold everything from Kodak film, cigars, clothing, and shoes to mausoleums. Down Cortlandt Street is a station of the elevated rail line. This block was later home to the Singer Building and today is One Liberty Plaza. (Irving Underhill, LOC.)

The Broadway Line streetcar opened in 1864 and was operated by the Metropolitan Street Railway Company and later the New York Railway. The Broadway Line ran from South Ferry to Central Park. This photograph was taken at Herald Square, with the Sixth Avenue elevated rail in the background. The streetcar line was replaced by the New York Omnibus Corporation bus line in 1936. (LOC.)

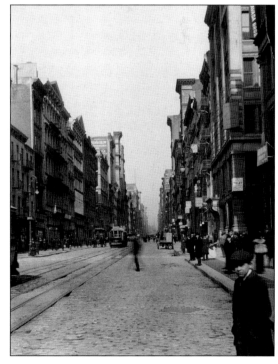

This 1916 photograph provides a look up Broadway into SoHo from Canal Street. Through a farmland grant, SoHo was first settled by slaves freed by the Dutch West India Company in 1644. It is also the site of the first free black settlement in Manhattan. In the 1800s, it was a wealthy neighborhood, with the land around Canal Street owned predominantly by John Jacob Astor. Hotels and stores dotted the fashionable residential and commercial district, later replaced in part by cast-iron architecture commissioned by local businessmen starting in the 1940s. The buildings were retail on the ground floor and manufacturing and offices above, with large windows to let in light. The strength of cast iron allowed architects to build with thinner walls, with the material prefabricated off site. (LOC.)

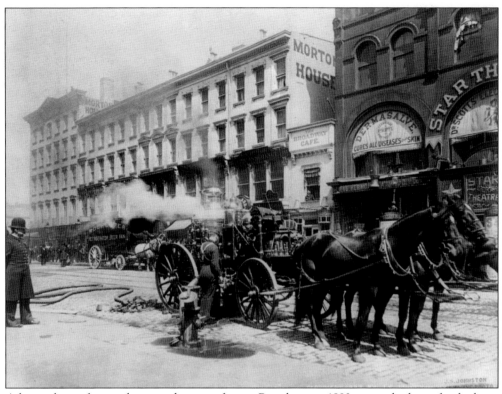

A horse-drawn fire truck responding to a fire on Broadway in 1893 is attached to a fire hydrant between Twelfth and Thirteenth Streets. In the background is the Star Theatre, formerly Wallack's Theatre, which opened in 1861. The theater was renowned for its productions, often starring theater greats. The area at the time was a stronghold for entertainment, but the industry moved uptown within a few decades. In 1901, the demolition of the Star Theatre was recorded in a time-lapse film. (LOC.)

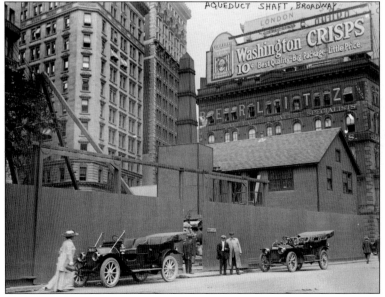

Sometime between 1910 and 1915, a temporary structure was built at Madison Square for the excavation of a shaft for the New York Aqueduct, part of the Catskill Aqueduct. The shaft went down 205 feet below the surface. There are 14 shafts in Manhattan for this aqueduct, but this is the only one on Broadway. (LOC.)

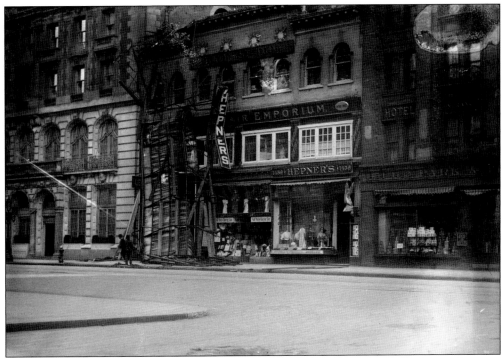

A 110-mile-per-hour wind in February 1912 knocked down a two- or three-ton electrical sign at Forty-third Street and Broadway from atop the Kohn Building. It shattered the window of the Lehigh Valley Railroad office on the ground floor and took down the sign for Hepner's Hair Emporium along the way. (LOC.)

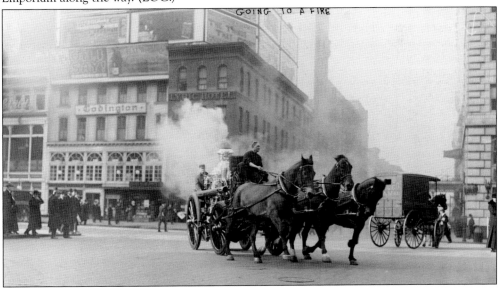

Between 1910 and 1915, a horse-drawn fire carriage crosses in front of the Lyric Hotel on Forty-third Street and Broadway. The Lyric Hotel also had a café on the property, known as Dowling's Café. In 1911, the *Tammany Times* called the Lyric Hotel "one of the most popular and best managed resorts in the White Way district." Hammerstein's Victoria Theatre occupied the rest of the block with the New York Times Building across the street. (LOC.)

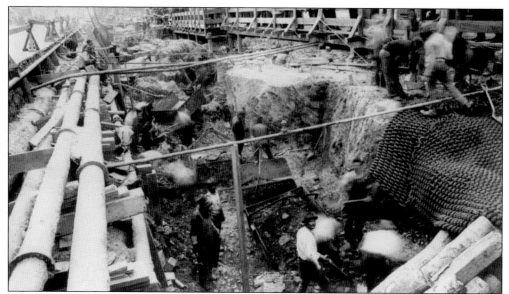

Shown here is the cut-and-cover construction of the Interborough Rapid Transit line at Broadway and Forty-fourth Street. When the subway debuted in 1904, Times Square was a local station. The area was not popular until the arrival of the New York Times Building. The station was later expanded, but there were no free transfers between the IRT and BMT lines until 1948, as they were run by different companies. (Irving Underhill, LOC.)

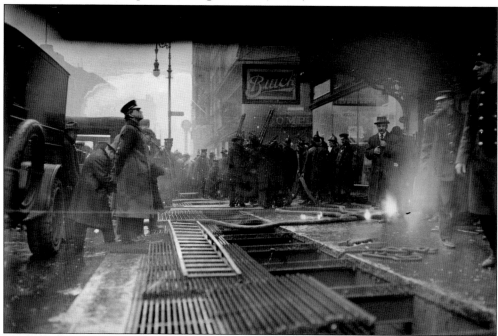

On January 6, 1915, an electrical short circuit set fire to the insulation cable underground, filling the subway tunnel at Fifty-fifth Street and Broadway with smoke. A woman was killed, and 210 people were overwhelmed by smoke or trampled in the accident. The *New York Times* reported morbidly that "screams of scores imprisoned under ventilator grating are heard in the street." (LOC.)

Three

WORLD'S TALLEST BUILDINGS ON BROADWAY

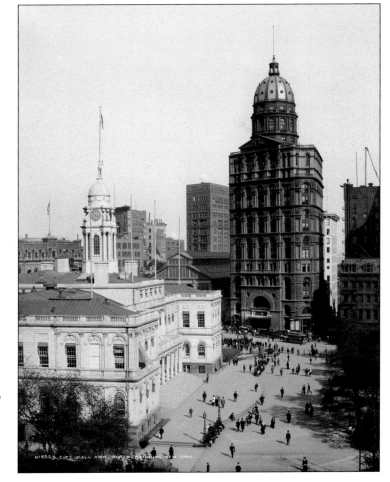

The New York World Building, commissioned by Joseph Pulitzer on Park Row, was the first skyscraper to surpass the height of Trinity Church. Pulitzer had his office in its dome. The 1890 building was demolished in 1955 to make way for a larger entrance ramp to the Brooklyn Bridge. (Detroit Publishing Co., LOC.)

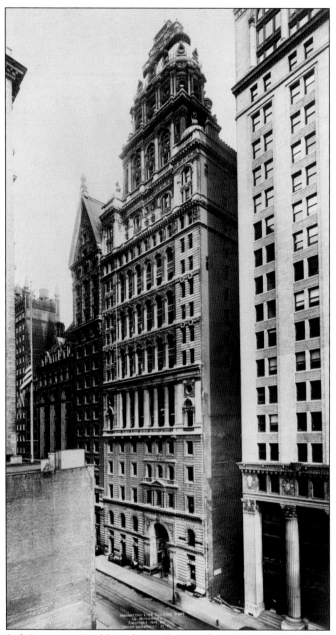

The Manhattan Life Insurance Building, located across from Trinity Church at 64–66 Broadway, surpassed the record of the New York World Building by nearly 40 feet just four years after the latter's completion. At 348 feet, it was the first building to be taller than 100 meters in New York City. The 1894 building was designed by Kimball and Thompson and was one of the first buildings heated and cooled using electric ventilation and was the first to use pneumatic caisson foundations, enabling supports to be laid without disturbing nearby buildings. The facade was extended by two bays in the early 1900s, and the cupola dome was updated to balance out the building's symmetry. It was demolished in the 1960s (there is debate as to the exact date) and replaced by an annex of the Irving Trust Company Building, which is now part of One Wall Street. (Irving Underhill, LOC.)

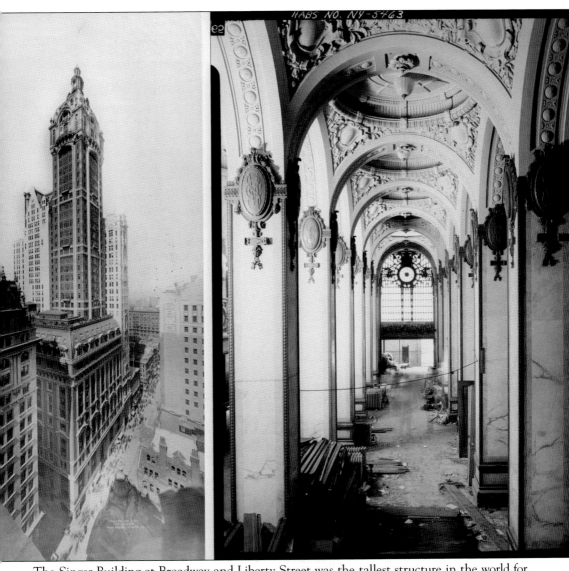

The Singer Building at Broadway and Liberty Street was the tallest structure in the world for 18 months. Built by architect Ernest Flagg in 1908, the building utilized a setback tower atop 12-story base. Flagg was an advocate of new regulations for skyscrapers, and some of his ideas were incorporated into the 1916 Zoning Resolution. Unfortunately, the setback of the Singer Building is precisely what doomed it. Its narrow tower portion rendered it economically unviable for office space, and it became the tallest building ever demolished in 1968. The interior photograph was taken before demolition, capturing the marble and bronze lobby. (LOC.)

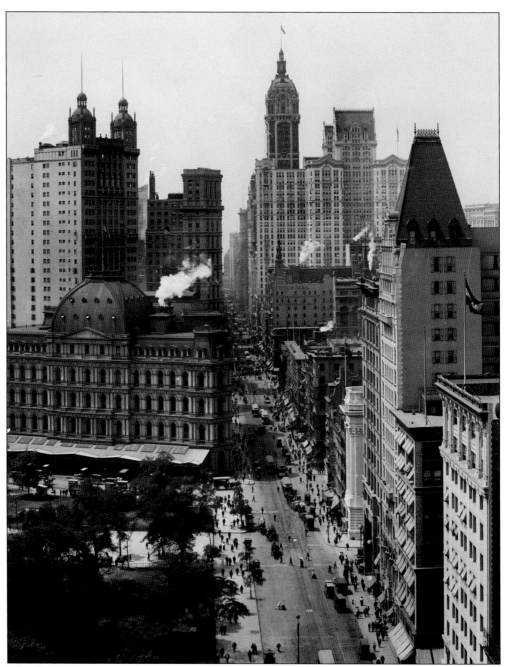

This photograph of Broadway looking south from Chambers Street includes the Singer Building, the City Investing Building, the Home Life Building, St. Paul's Building, the old post office, and the Park Row Building, which was the world's tallest structure for nine years until surpassed by the Singer Building. The Park Row Building, with the double cupolas, served as the first headquarters for the Interborough Rapid Transit (IRT) subway as well as the *Associated Press*. This photograph was taken in the early 1900s, before the Woolworth Building was constructed. Astor House is still standing, however. (Detroit Publishing Co., LOC.)

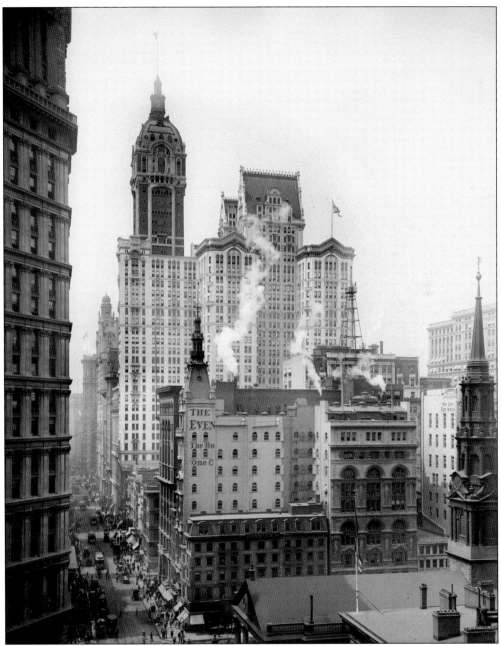

The view of Broadway shows St. Paul's Chapel and the Singer Building from the old post office. The large building in front of the Singer Building was the City Investing Building, constructed in 1908. It was the largest office building in New York at the time (though never the tallest). It was demolished in 1968 with the Singer Building. While there was much chagrin over the loss of the Singer Building, the City Investing Building was not missed. It was seen as a monument to greed during the Gilded Age, with an overbearing style of architecture built straight to the lot line. The buildings were replaced by the US Steel Building, now One Liberty Plaza. (Detroit Publishing Co., and Irving Underhill, LOC.)

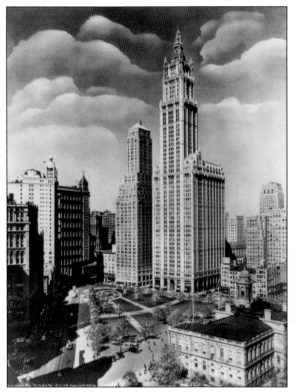

The magnificent neo-Gothic Woolworth Building was a speculative real estate development that housed the Woolworth store headquarters, Irving National Bank, and office space. The lavish Byzantine-style lobby of intricate mosaics and marble earned the building the unofficial title of "Cathedral of Commerce," dubbed by the Rev. S. Parkes Cadman. On the outside, the top of the building was originally layered with gold leaf. Constructed just after the sinking of the *Titanic*, the Woolworth Building was an engineering feat, designed to be as impervious as possible. Sixty-nine pneumatic caissons were sunk to 100–120 feet below grade, portal braces protected the building against wind, and elevator shafts were tapered to cushion a fall in case of emergency. The Woolworth Building elevators were the fastest in the world when the structure was completed in 1913. (Both, Irving Underhill, LOC.)

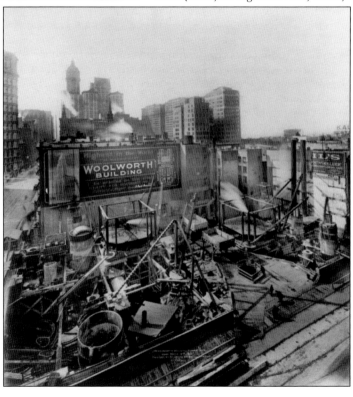

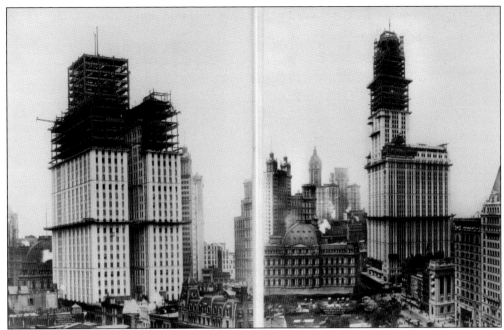

The office block base at the back of the Woolworth Building had an interior courtyard to allow in light. Photographs taken while in construction show the structural steel frame that was the main support for the building. The exterior was clad in terra-cotta from the Atlantic Terra Cotta Company with Gothic detailing, a style utilized to emphasize the verticality of the building. The lower floors were made of Indiana limestone, the upper floors of white-gray face brick to contrast with the sky. The height of the building was planned deliberately to surpass the Singer Building and the Metropolitan Life Insurance Tower at Madison Square and topped out at 729 feet. At the opening of the Woolworth Building, United States president Woodrow Wilson pushed a button to signal the lighting of the structure. Architect Cass Gilbert later said that the building's form was inspired by the ever-increasing need for height that Woolworth demanded and was not an embodiment of the 1916 Zoning Resolution. (Above, Irving Underhill, LOC; below, Detroit Publishing Co., LOC.)

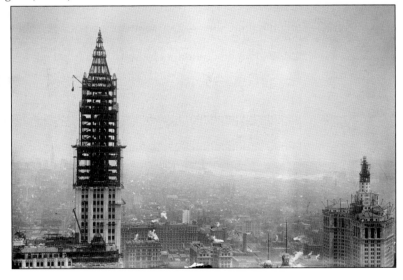

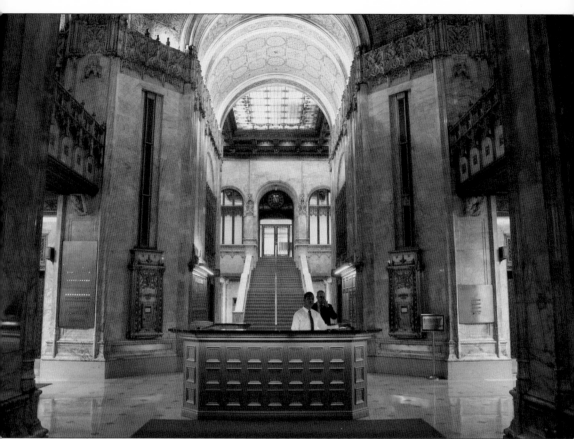

The Woolworth Building lobby is as equally, if not more, inspiring than the exterior. The transept floor plan is matched by vaulted ceilings covered in mosaics. Walls of marble surround the interior. A stained-glass skylight sits above a grand staircase that once led to the headquarters of Irving National Bank, a partner in the venture to construct the Woolworth Building. Gilbert conceived of the space as a monumental civic space, with ground floor retail. Gothic details extended to the elevators and signage, which are decorated with bronze tracery. Sculpted figures depicting Woolworth, Gilbert, and Lewis Pierson, of Irving National Bank, as well as others involved in the construction of the building, adorn the lobby. In the basement were entrances to the BMT and IRT subway lines, along with the vault of the bank and a pool that still exist today. (Michelle Young.)

The Equitable Building, shown under construction here, had the largest total floor area in the world when it was finished in 1915. At 40 stories and with no setbacks, the building cast a seven-acre shadow on Broadway. Reaction to this structure influenced the required building setbacks of the 1916 Zoning Resolution, the first comprehensive zoning ordinance in the United States. The building was designed by Ernest R. Graham, of the firm Daniel H. Burnham & Company. The arcade-style lobby has marble floors, marble walls, and a coffered ceiling. The elevator banks are faced with marble, and the offices were built with mahogany trim. The building replaced the first office of the company (below) that burned in 1912. (All, Irving Underhill, LOC.)

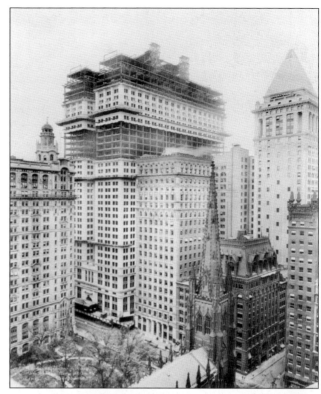

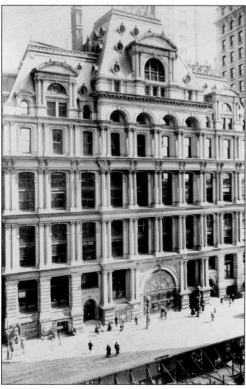

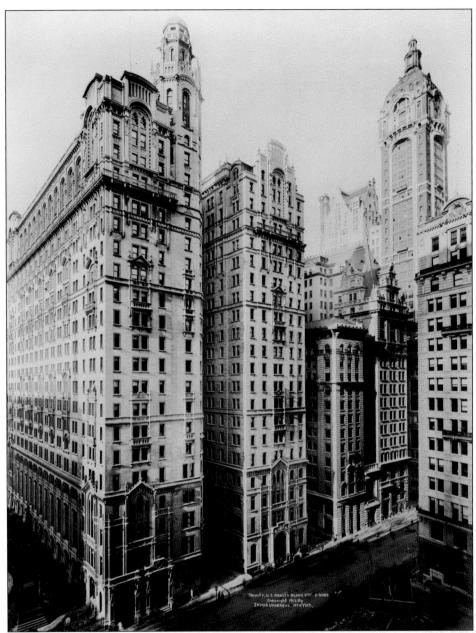

The Trinity and US Realty Buildings sit side-by-side at 111 and 115 Broadway, ornamented in a Gothic style to compliment Trinity Church. Designed by the same architect, Francis Kimball, but constructed two years apart, the two buildings are connected by a steel-and-iron skybridge at the roof. Built from 1904 to 1907, the buildings were constructed before the 1916 Zoning Resolution, so do not have a setback. The Trinity Building was one of the first skyscrapers to use Gothic style for an office structure. The exterior material is of limestone, and the lobby features bronze ornamentation and ceiling paintings. The foundations were laid with pneumatic caissons, a technique introduced by Kimball with the Manhattan Life Building. To accommodate the twin buildings, Thames Street was moved 28 feet north and Temple Street was closed permanently. (Irving Underhill, LOC).

Four

BROADWAY'S FAMOUS PLAZAS

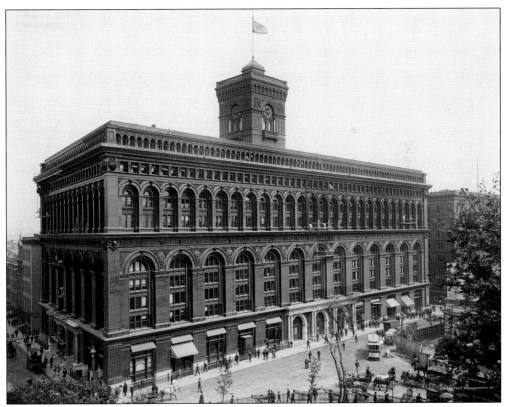

In the 19th century, the New York Produce Exchange was located at 2 Broadway across from Bowling Green. George B. Post constructed this brick Romanesque Revival building using cage construction, a foreshadowing of future skyscraper technique. Prices for global commodities like oil, wheat, and corn were set here. In 1900, $15 million worth of business passed through the exchange each day. The building was demolished in 1953. (Detroit Publishing Co., LOC.)

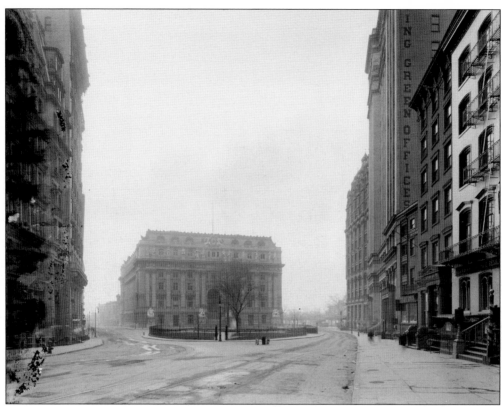

When Fort Amsterdam was demolished in 1790, the land was dedicated for public use. When the proviso was repealed, the city subdivided the land and auctioned off parcels to private citizens. When the area became less fashionable, steamship companies moved into the former mansions, giving the stretch the nickname of "Steamship Row." The Alexander Hamilton US Custom House, designed by Cass Gilbert, was constructed between 1902 and 1907 in place of the steamship offices. The low-rise structures along Broadway in the 1865 stereoscope image below were later replaced by skyscrapers such as the Standard Oil Building. (Above, Detroit Publishing Co., LOC; below, George Stacy, LOC.)

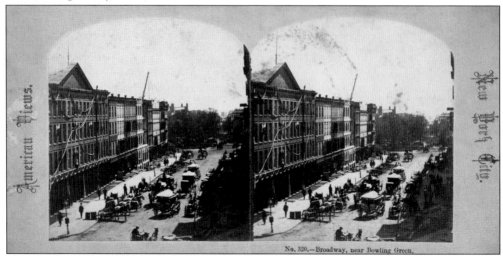

No. 320.—Broadway, near Bowling Green.

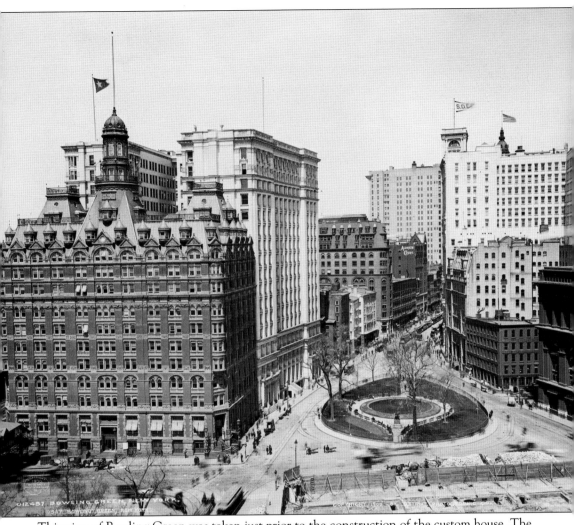

This view of Bowling Green was taken just prior to the construction of the custom house. The ornate Washington Building at 1 Broadway was constructed in 1884 by Edward H. Kendall on the site of the former Washington Hotel. The building still stands today, but its facade was fully remodeled by the International Mercantile Marine Company (now United States Lines). At the time of this photograph, the Standard Oil Building had not been constructed. (Detroit Publishing Co., LOC.)

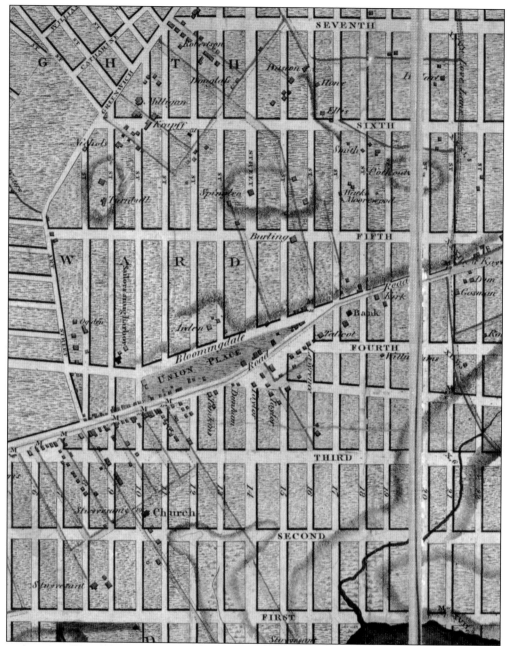

Union Square, a former potter's field (common grave site), began as Union Place, mapped out as just a sliver in the original Commissioners' Plan. Nonetheless, it was one of the few open spaces designated in the street plan. It also marked the location where Broadway turned into Bloomingdale Road. The name Union Place is derived from its location at the union of the Bowery and Broadway. (LOC.)

In the 1830s, real estate developer Samuel Ruggles campaigned for Union Place to become a public space. In 1839, Union Park opened, with an oval design featuring some of the city's first gaslights, a central fountain, and radial paths. The surrounding neighborhood had also become a fashionable residential district for wealthy New Yorkers. (LOC.)

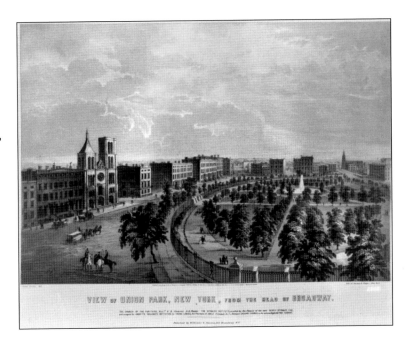

VIEW OF UNION PARK, NEW YORK, FROM THE HEAD OF BROADWAY.

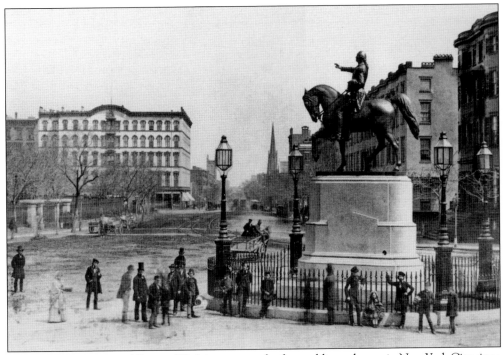

An 1856 bronze statue of George Washington was the first public sculpture in New York City since that of George III in 1770. It originally stood outside Union Park on Fourth Avenue but is now located at the southern end of Union Square Park. The sculpture celebrates Evacuation Day, the date the British left New York and when George Washington led the American troops back into the city. (From *New York Then and Now* [2005] by Marian Reiss, sourced from Wikimedia Commons.)

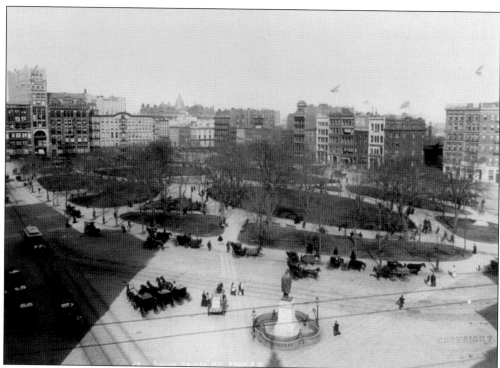

In 1871, landscape architects Frederick Law Olmsted and Calvert Vaux, who had completed Central Park in 1857, unveiled a new design for Union Park. The enclosed fence was removed, the sidewalks around the park widened, new trees were planted, and a muster ground for the military was added, as were stands to accommodate a public requirement for mass meetings. (J.S. Johnston, LOC.)

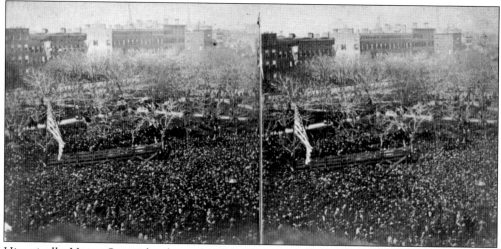

Historically, Union Square has been the site of many meetings, demonstrations, and speeches, including rallies for the Union during the Civil War, the nation's first Labor Day parade in 1882, the first suffragette parade, an anarchist bombing, and the funeral processions of presidents Abraham Lincoln and Andrew Jackson. Pictured above is the Union meeting of 1861, attended by about 200,000 people. Union Square has continued its role as a gathering place for political protest through the Vietnam War and into the present day. (E. Anthony, LOC.)

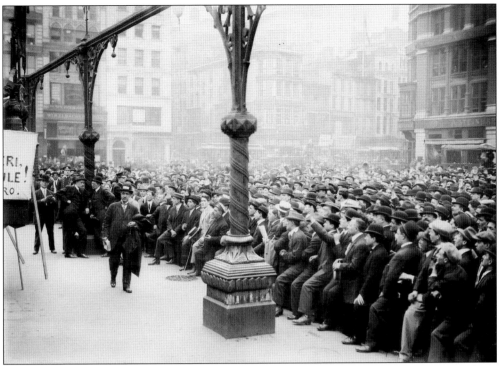

Labor leader Joseph James Ettor is speaking to striking barbers during the Brooklyn Barbers' Strike of 1913 at the Union Square stands. The Industrial Barbers Union was an organization within the Industrial Workers of the World. They demanded a shorter, 12-hour workday and a 6-day work week. The union was granted their demands. (LOC.)

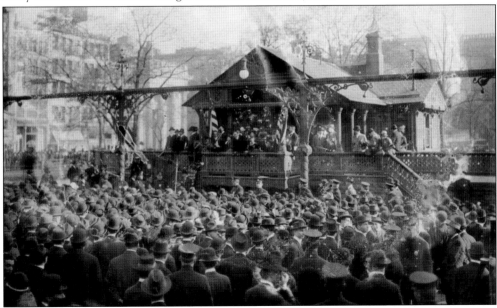

This image shows a socialist and labor union demonstration on International Labor Day (May Day) in 1914 at the Union Square pavilion, which no longer exists. In the background is a Neoclassical-style bank from the 19th century that still exists and is now a historic landmark. (LOC.)

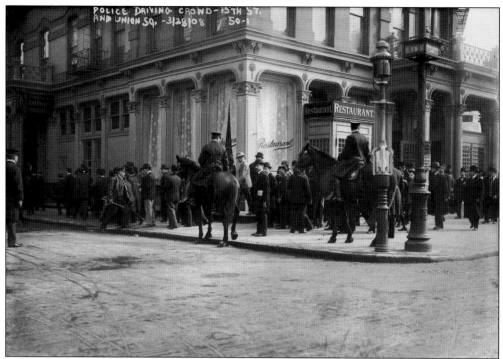

In 1908, an anarchist attempted to throw a bomb in Union Square during a socialist meeting, but it prematurely detonated, killing a bystander and mortally wounding the bomber, a Russian member of the Anarchist Federation of America. In this photograph, mounted police drive crowds from the scene of the bombing. (LOC.)

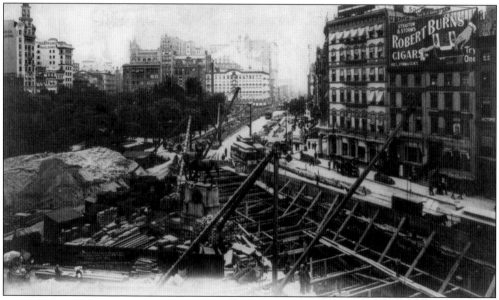

In 1901, construction of the Interborough Rapid Transit, the first subway line in New York City, was taking place at Union Square along Fourth Avenue using the cut-and-cover method. The subway was built below a former streetcar line. The IRT was built in sections, with the Union Square area in the third section of construction. (Irving Underhill, LOC.)

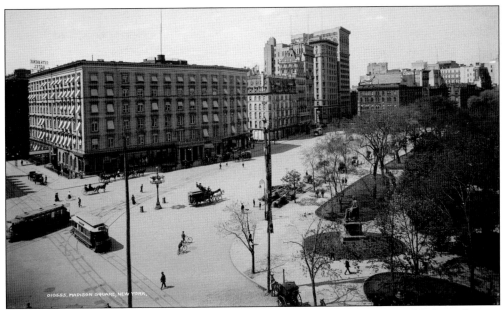

The steady march of upscale residences made its way from Union Square to Madison Square, following the path of Ladies' Mile, a stretch of department stores along Fifth Avenue. The building closest in both photographs is the Fifth Avenue Hotel. The monument at the triangular intersection is Worth Monument, the second-oldest major monument in the New York City parks, in honor of Gen. William Jenkins Worth, a veteran of the War of 1812 and the Mexican-American War. (Both, Detroit Publishing Co., LOC.)

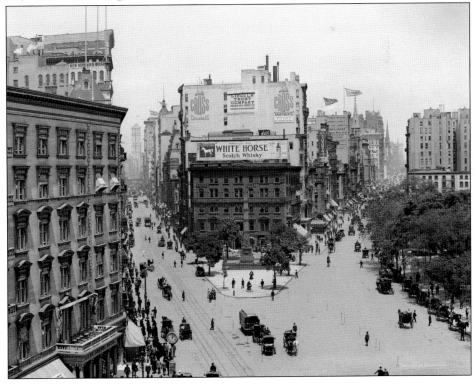

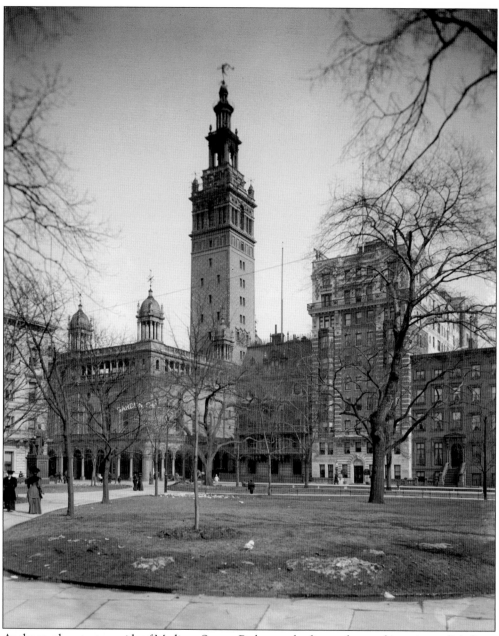

At the southeast corner side of Madison Square Park were the first and second iterations of Madison Square Garden. Stanford White's 1890 Moorish-style building had a 33-story tower, making it the second-tallest skyscraper in the city, topped with an 18-foot statue of a nude Diana. In addition to a main space that fit 8,000 people, the second Madison Garden had a café, restaurant, and rooftop theater. In addition to being an architect, Stanford White was a famous playboy. He had an apartment inside the Madison Square Garden tower and often took in the entertainment on the rooftop garden. In 1906, the jealous husband of White's former mistress, actress Evelyn Nesbit, shot and killed the architect on the roof. The second Madison Square Garden was demolished in 1925 and replaced by the new headquarters of New York Life Insurance. The Diana sculpture is now in the collection of the Philadelphia Museum of Art. (Detroit Publishing Co., LOC.)

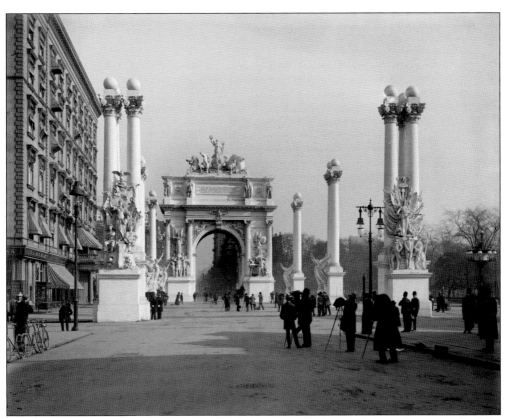

The Dewey Arch was a temporary monument at Madison Square Park to commemorate Commodore George Dewey's victory over the Spanish at Manila Bay in 1898. It was built in 1899 by Charles R. Lamb using staff, the same material used in the temporary structures at the World's Columbian Exposition in Chicago. Earlier in 1899, two additional arches were constructed to commemorate the centennial of George Washington's first inauguration. (Detroit Publishing Co., LOC.)

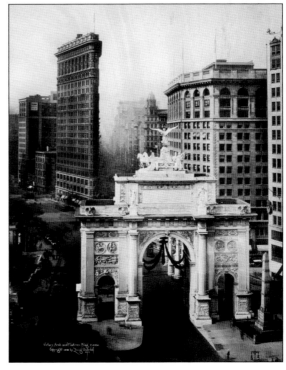

The Victory Arch was another temporary, monumental arch of wood and plaster to commemorate New Yorkers who died in World War I. Designed by Thomas Hastings, it was modeled after the Arch of Constantine in Rome and installed at Madison Square in 1918 at a cost of $80,000. Plans to make it permanent fell through, and it was eventually demolished. (Irving Underhill, LOC.)

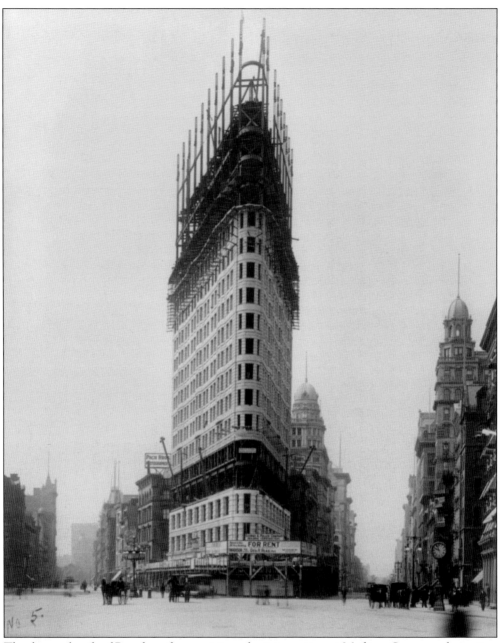

The diagonal path of Broadway forms a triangular intersection at Madison Square, culminating in the iconic Flatiron Building, constructed in 1902. Architect Daniel Burnham, the master of architectural ceremonies at the World's Columbian Exposition in Chicago, put forth a building of steel-cage construction and limestone. Its official name is the Fuller Building. (Charles R. Ritzman, LOC.)

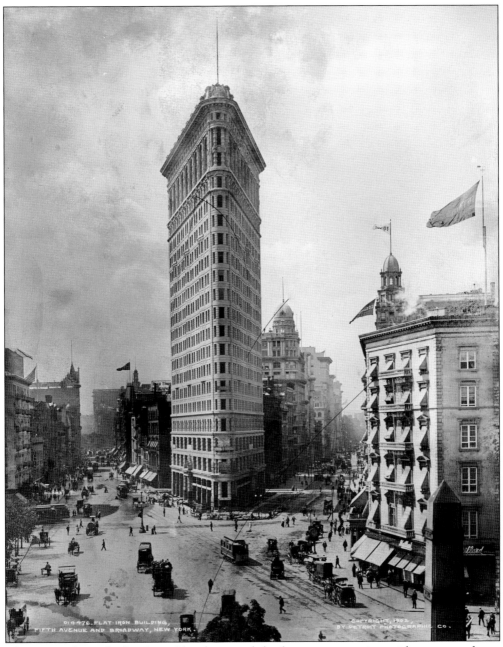

This image shows the hustle and bustle around the famous intersection, with streetcars, horse carriages, and pedestrians haphazardly crossing. (Detroit Publishing Co., LOC.)

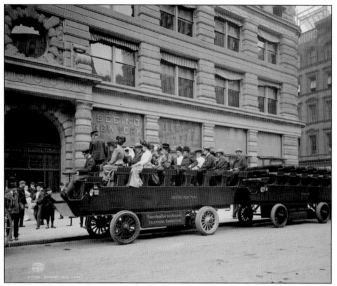

The Flatiron Building was such a popular tourist destination that Seeing New York operated its open-air New York City tours from the structure every hour, all seven days of the week, for $1. Seeing New York operated four sightseeing tours, listed as follows: downtown to Little Italy, Five Points, Chinatown, and the Bowery; uptown to Central Park, Fifth Avenue, and Riverside Drive; Chinatown by night; and a yacht tour around Manhattan. (Detroit Publishing Co., LOC.)

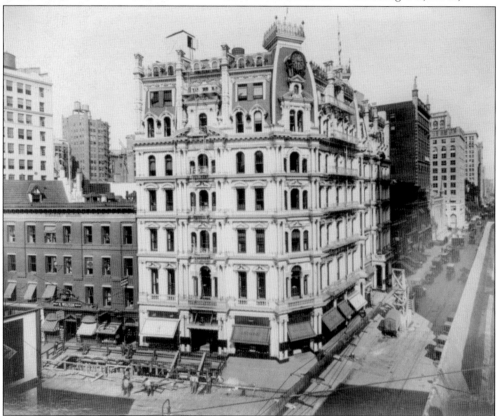

The luxurious French Second Empire–style Gilsey House hotel opened in 1872 on Twenty-ninth Street and Broadway and is now a New York City landmark. It was the first hotel in the city to have telephone service and was a favorite haunt of Oscar Wilde, Mark Twain, and those in the theater community. Its cast-iron facade deteriorated after the hotel's closure in 1911 but was restored in 1992. (LOC.)

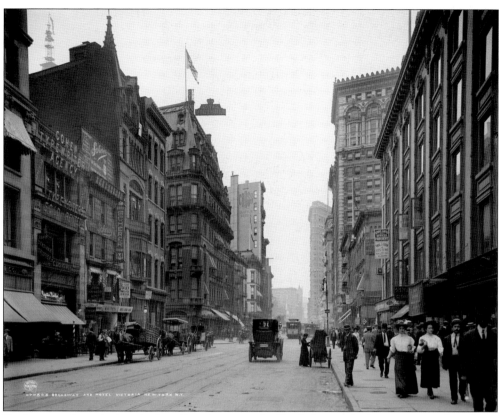

Farther west from the hotels along Broadway was the Tenderloin, a shadow economy of gambling houses, dance halls, and brothels that supported the luxury hotel industry. The Tenderloin had its peak between 1870 and 1910 and thrived with the assistance of the police. The famed luxury Hotel Victoria was located on this stretch of Broadway. (Detroit Publishing Co., LOC.)

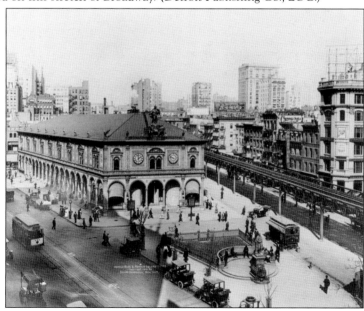

Herald Square can trace its origin to 1846, when the city acquired the land to extend Bloomingdale Road, now Broadway. The plaza is named after the *New York Herald*, the newspaper company led by James Gordon Bennett Jr. He commissioned a Renaissance palazzo–style headquarters from Stanford White at the triangular intersection. (Irving Underhill, LOC.)

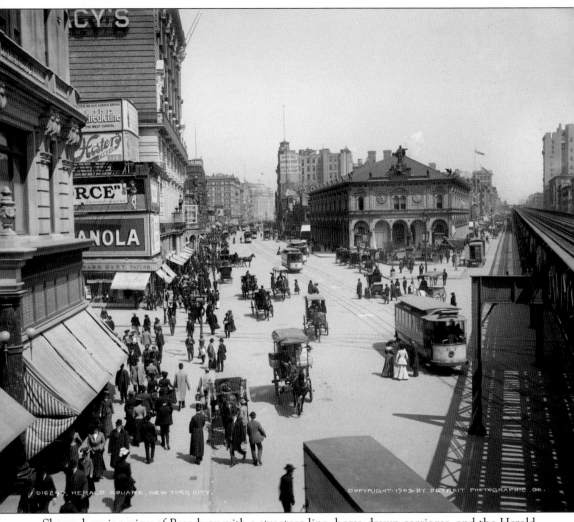

Shown here is a view of Broadway with a streetcar line, horse-drawn carriages, and the Herald Building in the background, modeled closely after the Palazzo del Consiglio in Verona. It was demolished in 1921 but some details remain: two of the bronze owls that once decorated the facade are now on the Herald Square monument and the building clock is also in the square. Owls were a particular obsession of Gordon Bennett Jr., who also commissioned Stanford White to build him a 125-foot owl statue that would hold his future coffin. (Detroit Publishing Co., LOC.)

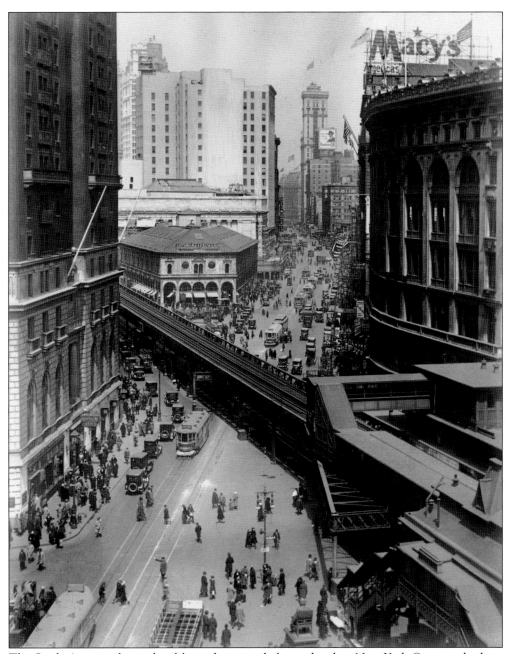

The Sixth Avenue elevated rail line, the second elevated rail in New York City, was built in 1878. After the community rallied for its removal, it was replaced by the underground subway and demolished in 1939. (Detroit Publishing Co., LOC.)

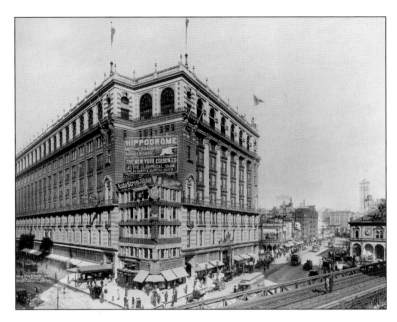

Macy's department store made the move from Fourteenth Street and Sixth Avenue to Herald Square in the 1890s under the leadership of Isidor and Nathan Straus. Though the store was accessible by mass transit, the owners ran a steam wagonette between Fourteenth and Thirty-fourth Streets initially to encourage customers to venture north. (Irving Underhill, LOC.)

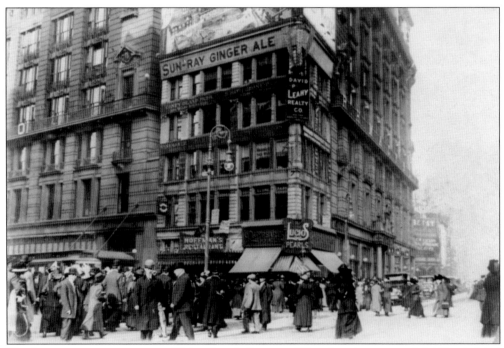

The five-story corner property at Thirty-fourth Street and Broadway is now mostly hidden behind an oversized Macy's bag, but it was once known as the Million Dollar Corner. In 1911, it was the highest amount ever paid for a plot of land. At just 1,200 square feet, the irregular plot of land came out to $868 per square foot. (LOC.)

Macy's had wanted to purchase the corner property but was outbid by Henry Siegel of the Siegel-Cooper store, who wanted Macy's Fourteenth Street building in exchange. Macy's did not cave, and by 1931, the building was already covered in billboard advertisements. Today, the Macy's shopping bag sign is displayed through a lease agreement between the building owners. (Irving Underhill, LOC.)

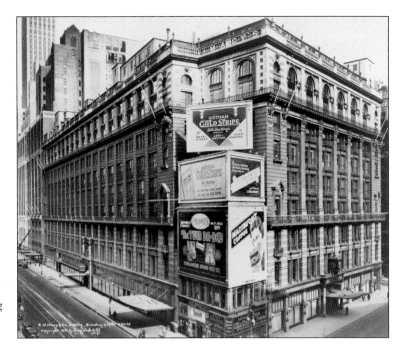

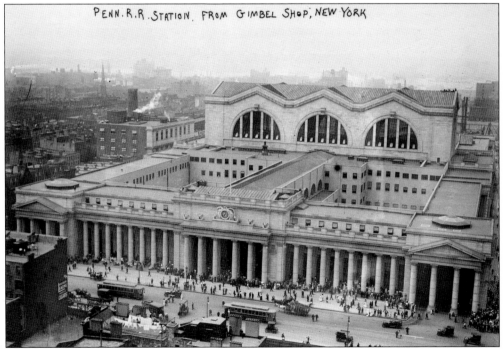

Just nearby on Broadway was the Gimbel and Brothers department store, home of the Manhattan Mall today. In the early 20th century, Gimbel's also had a view of the original Pennsylvania Station (above), designed by Stanford White. A remarkable sky bridge over Thirty-second Street connected the main store to its annex and still exists today. The original Pennsylvania Station was demolished in 1963. (LOC.)

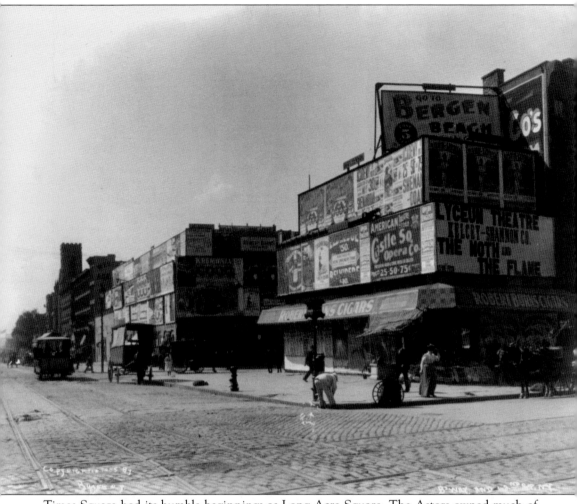

Times Square had its humble beginnings as Long Acre Square. The Astors owned much of the land around Times Square, and the commercial area was also once the site of William H. Vanderbilt's American Horse Exchange. At the turn of the century, the buildings were still low-rise but already had billboard posters over them. The stone streets were traversed by streetcars, horse-drawn carriages, and wagons. In this photograph, a sanitation worker is cleaning out the gutter at the street corner at Forty-second Street and Broadway. *The Moth and Flame* is playing at the Lyceum Theater, dating this image to around 1898. (LOC.)

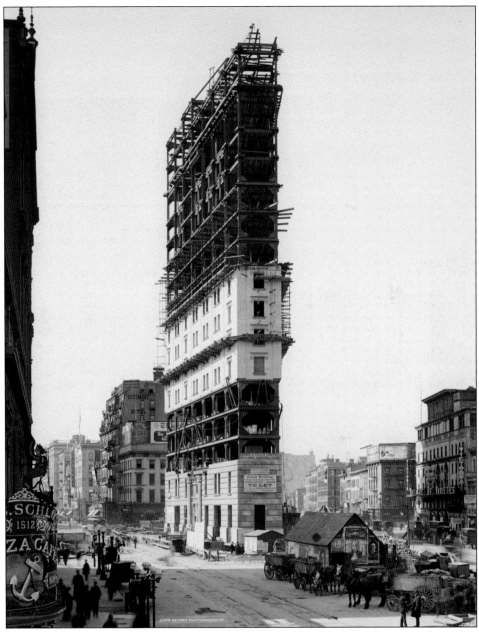

The *New York Times* moved to Long Acre Square on December 31, 1903, celebrating the occasion with fireworks, now the annual New Year's Eve tradition with the New Year's Eve ball introduced in 1908. The narrow building at Forty-second Street between Broadway and Seventh Avenue, now known as One Times Square, was the newspaper's headquarters until 1913, when the *New York Times* built a new annex on West Forty-third Street. One Times Square was built atop the site of the former Pabst Hotel. The original facade of One Times Square was granite and terra-cotta, but it was later reclad with marble in the 1960s. In 1995, Lehman Brothers bought One Times Square for $27.5 million to retrofit as an advertising billboard instead of office space. The wildly profitable building was worth $495 million in 2012 despite being virtually empty on its upper floors. Today, the New Year's Eve ball is stored at the top of the building. (Public Domain via Wikimedia Commons.)

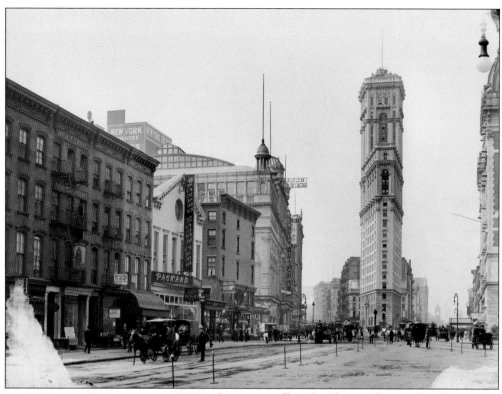

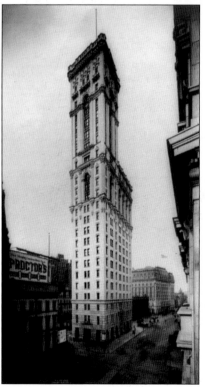

Low-rise, walk-up buildings still existed in Times Square in 1905. They housed neighborhood businesses like tailors, clothiers, and a dentist, as well as services related to the horse-and-carriage industry. The New York branch of Packard Motor Cars, seen in the above photograph, was open from 1904 to 1907, whereupon it moved to Sixty-first Street and Broadway. At left is the New York Times Building, now One Times Square, around 1906. (Above, Detroit Publishing Co., LOC; left, Irving Underhill, LOC.)

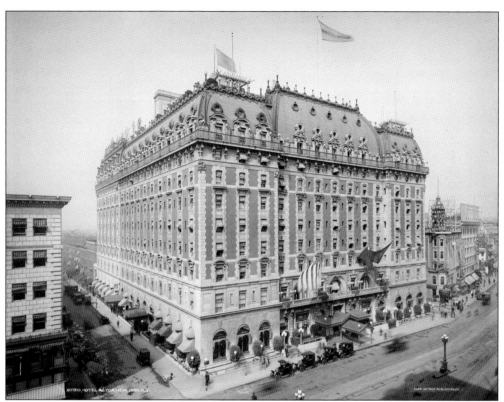

In 1905, the Hotel Astor, conceived by William Waldorf as the next iteration of the Waldorf-Astoria Hotel, was the first of the hotels to arrive in Times Square. The French-inspired building on Broadway between Forty-fourth and Forty-fifth Streets had a green copper mansard roof, a Louis XV–style Rococo ballroom, and a rooftop garden for entertainment, drinking, and dining. The hotel was designed by New York architect Charles W. Clinton and Connecticut architect William H. Russell and built atop former farmland. After changing ownership several times, the Hotel Astor was demolished in 1967. It lives on as an illustration on Dr. Brown's Soda cans. Today, the site is home to 1 Astor Plaza, which contains MTV Studios, Viacom, and the Minskoff Theatre. Next door to the Hotel Astor was the Astor Theatre, which was demolished in 1982 and replaced by the Marriot Marquis hotel. (Above, Detroit Publishing Company, LOC; below, George Grantham Bain Collection, LOC.)

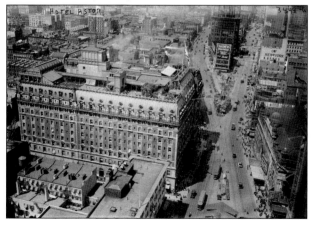

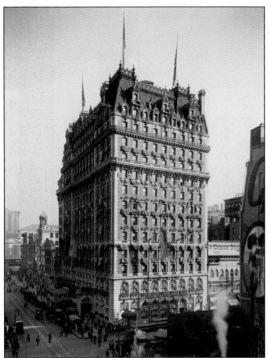

John Jacob Astor IV, a longtime rival of William Waldorf, built the Knickerbocker Hotel in 1906 on West Forty-second Street and Broadway. Known in its heyday as the "42nd Street Club," the French chateau–style hotel also had an entrance directly to the subway platform below that still exists today, though closed off. It is also alleged that the Knickerbocker is where the martini was invented. The Knickerbocker Hotel reopened in 2015. (Detroit Publishing Co., LOC.)

The New York Theatre Company building on Broadway between Forty-fourth and Forty-fifth Streets was constructed by Oscar Hammerstein in 1894 as the Lyric Theatre. Demolished in 1935, it was also known as the Olympia and the Criterion. The large building included a roof garden, billiard room, concert hall, music hall, and a theater. (Detroit Publishing Company LOC.)

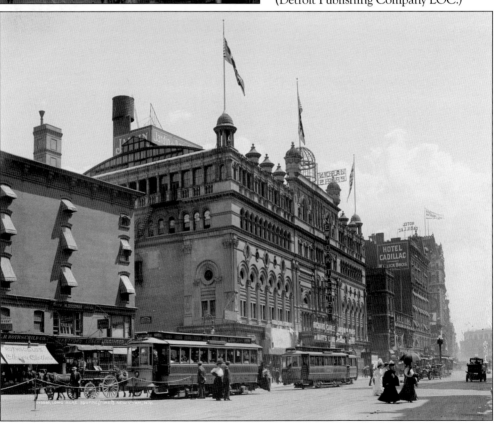

The image at right is a view looking up Broadway from about Thirty-ninth Street to the New York Times Building and Hotel Astor. The first Metropolitan Opera House is on the left. The photograph below appears to have been taken from the New York Times Building and shows the Hotel Astor, and the New York Theatre Company. The six-story building on the left would be demolished and replaced by the Paramount Theater and offices in 1926. (Right, Detroit Publishing Co., LOC; below, Irving Underhill, LOC.)

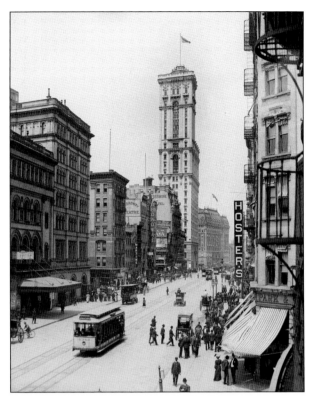

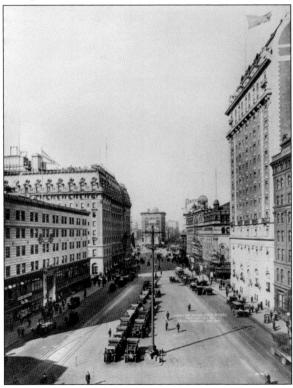

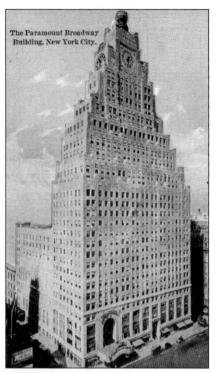

The Paramount Broadway Building, New York City.

The Paramount Theatre opened in 1926 as the headquarters of Paramount Pictures and included a showcase movie theater for the company. Notable live performances at the venue included visits by Frank Sinatra, whose presence incited a riot among fans in 1944. The photograph below, from 1933, shows the elaborate marquee of the Paramount Theatre. Also pictured is the former subway entrance at Times Square. Cast-iron entrances were installed at every stop of the IRT subway line in 1904 but were removed by the 1950s. In the background of the photograph are the Astor Hotel, the Criterion Theater, Loew's New York Theater, and the Hotel Claridge. (Left, author's collection; below, Irving Underhill, LOC.)

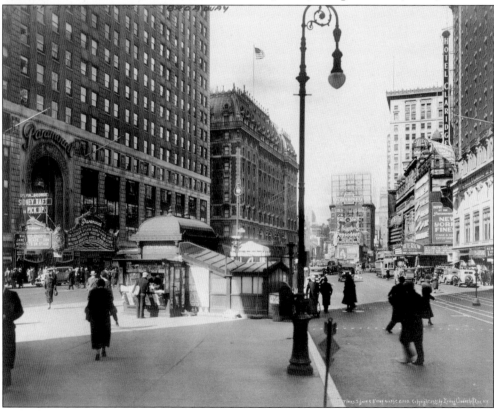

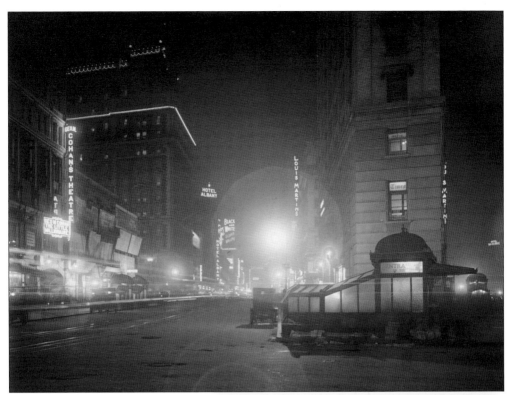

The area in front of the New York Times Building was witness to both quiet and crowded moments. In the above image, Broadway is photographed at night from the foot of the New York Times Building, with the cast-iron entrance to the subway shown. In the photograph at right from 1908, crowds gather to see a projected film at the building. In 1919, a large crowd would gather to get updates on the World Series, which had been fixed in the great Chicago White Sox scandal. Times Square was also a focal point for parades, war updates, war celebrations, and more. (Both, LOC.)

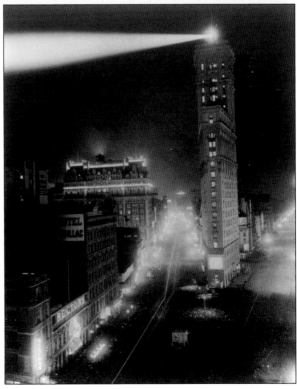

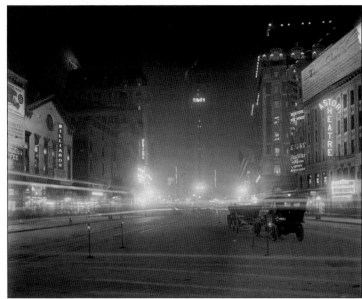

This image shows Times Square at night, with a view of the New York Times Building, Hotel Astor, Astor Theatre, and New York Theatre. Taken sometime between 1904 and 1915, at this point the New York Times Building has a new electrical sign on top. By this time, Packard Motor Cars has been replaced by a billiard hall. (Detroit Publishing Company, LOC.)

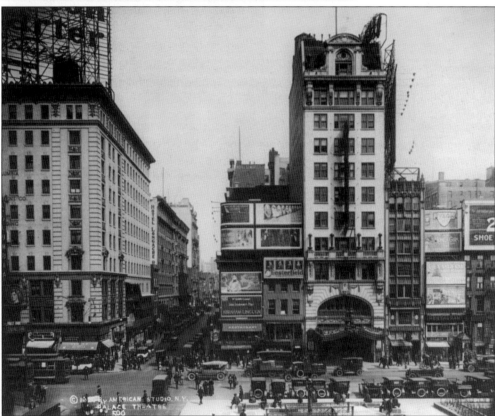

In the 1920s, the theater district in and around Times Square reached a new record, with 264 shows produced in 76 theaters. The Palace Theater, shown here, in Times Square became the center of vaudeville. Today, the theater still exists but is completely plastered over by signage. Notable Broadway shows in the Palace have included *Beauty and the Beast* and *Aida*. (LOC.)

The Knickerbocker Theater, Casino Theater, and Maxine Elliott's were all situated on Broadway between Thirty-eighth Street and Forty-second Street. A sign here advertises the Winter Garden on Fiftieth Street, the only one of these theaters still standing. Photographed around 1920, the Metropolitan Opera House had not yet been built on Thirty-ninth Street. (LOC.)

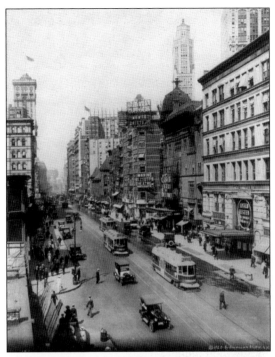

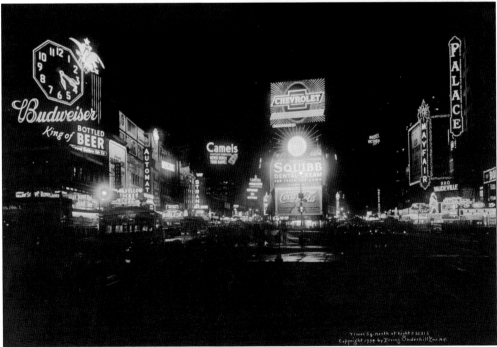

By the 1930s, Times Square was very much an advertising canvas. Its nickname, the "Great White Way," is a reference to the glow of the electric lights. Advertising in this era was dominated by American brands like Budweiser, Chevrolet, and Coca-Cola but interspersed are the signage for theaters, automats, and burlesque shows. The conversion of theaters into grind houses in Times Square would begin during the Great Depression. (LOC.)

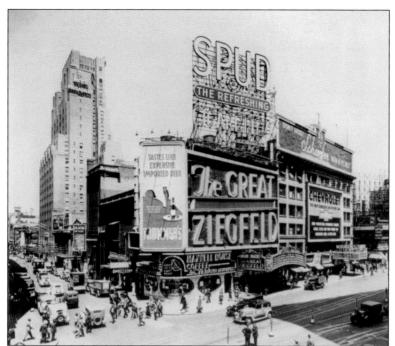

The Great Ziegfeld, an opulent film about the Ziegfeld Follies, premiered at the Astor Theatre on Broadway and Forty-fifth Street in 1936. The real Follies performed at the New Amsterdam Theater on Forty-second Street from 1913 to 1927 and later at Winter Garden and the Ziegfeld Theatre. (LOC.)

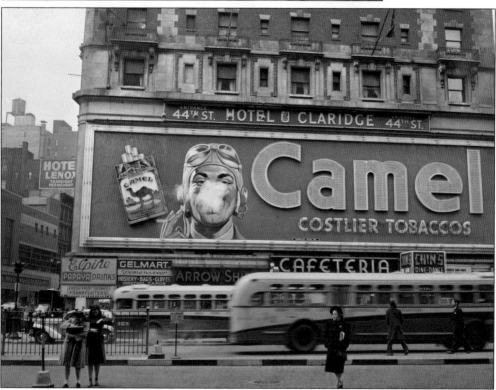

The Camel Man advertisement on the Claridge Hotel is one of the most iconic in Times Square history. The image would vary during World War II to show men in different branches of the armed services, always blowing smoke. (John Vachon, LOC.)

This image was taken on Victory over Japan Day (V-J Day) on August 14, 1945. This version, entitled "Kissing the War Goodbye," was taken by US Navy lieutenant and photojournalist Victor Jorgensen at a different angle compared to the iconic photograph of the same subject by Alfred Eisenstaedt. (Lt. Victor Jorgensen, National Archives.)

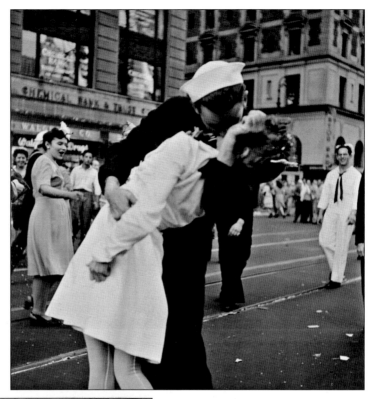

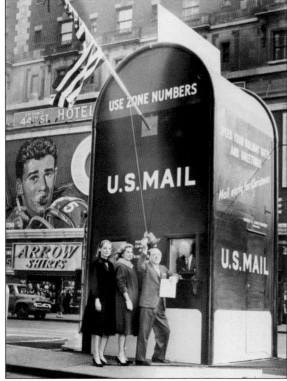

By 1960, the *New York Times* was describing Forty-second Street as the "worst block in town," with a proliferation of porn theaters, peep shoes, adult book and video stores, and other adult fare. Times Square itself still remained a place for over-the-top displays, like this giant post office booth run by the USPS. (Phyllis Twachtman, LOC.)

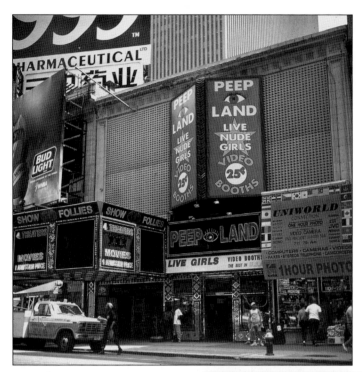

The crime and seediness of Times Square would only escalate in the 1970s and 1980s. In 1973, a "vice map" was made by the newly created Office of Midtown Planning and Development. In addition to the pornography theaters and bookstores, the map located "presumed prostitution hotels," single-room occupancy (SRO) hotels, massage parlors, spas, and live burlesque shows. This photograph was taken in the 1990s. (Gregoire Alessandrini.)

In 1982, there were 2,300 crimes on the Forty-second Street block of Times Square alone, of which one-fifth were serious felonies. But the bright lights of Times Square advertisements went on. This photograph was taken between 1980 and 1990. (Carol M. Highsmith Archive, LOC.)

The exterior of the New York Times Building was radically altered by Allied Chemical, who bought the structure in 1963. The original granite and terra-cotta exterior was replaced with marble in a $10 million renovation. In 1964, artists Christo and Jean-Claude hoped to wrap the entire building, but they were turned down by the board of Allied Chemical. (Tequask, Wikimedia Commons.)

Starting in the 1980s and 1990s, Forty-second Street was targeted for redevelopment, with Disney taking over the New Amsterdam Theater in 1995. As part of the agreement, Disney required the city to remove the pornographic shops on Forty-second Street. This photograph shows Forty-second Street mid-redevelopment. (Michael Minn.)

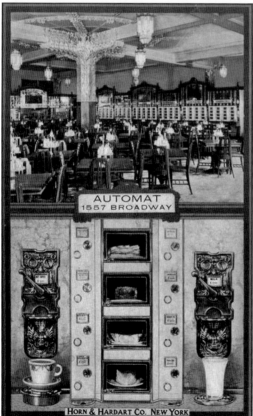

AUTOMAT
1557 BROADWAY

HORN & HARDART CO. NEW YORK

In 1997, the entire Empire Theater on Forty-second Street was lifted from its foundation and moved 168 feet westwards. The former theater was converted into the entrance of a new, larger complex, but historic remnants can still be seen today inside the lobby of the AMC Movie Theater. (Gregoire Alessandrini.)

There are few remnants of the craze for automats that once swept the city in the early 1900s. Automats were proto fast food establishments, where customers could procure prepared foods from sleek cases after dropping a dime or nickel. This postcard shows the inside of a Horn & Hardat automat on Forty-seventh Street and Broadway. (Mid-Manhattan Library Picture Collection, NYPL.)

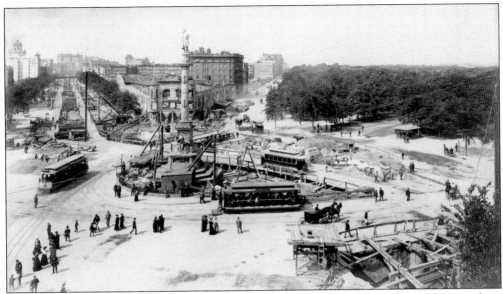

A subway stop at Fifty-ninth Street was included in the original Interborough Rapid Transit line. The photograph, taken in 1901, shows construction of the subway using the cut-and-cover method at Columbus Circle. Temporary structures for the construction surround the Christopher Columbus statue, and excavation is seen going northwards along Broadway. (Irving Underhill, LOC.)

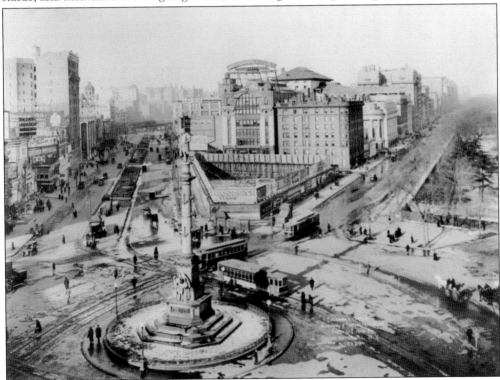

All official distances to and from New York City are measured from Columbus Circle, a practice that began shortly after the dedication of the Christopher Columbus statue in 1892. The original cast-iron entrances of the IRT subway line can be seen in this photograph. (Irving Underhill, LOC.)

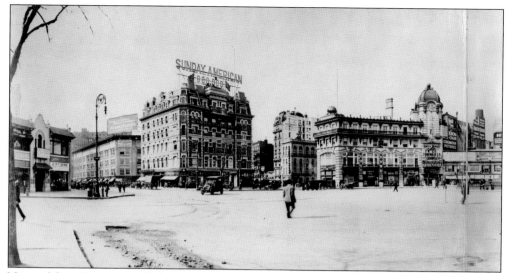

None of these Victorian-style buildings survive today at Columbus Circle. At left was the United States Tire Company, now the Museum of Arts and Design. On the right were Pabst Grand Circle and the Majestic Theatre, built for the Pabst Brewing Company in 1903. It was demolished in 1954 and replaced by the New York Coliseum, a convention center that was demolished in 2000. Today, it is the site of the Time Warner Center, which opened in 2004. (Irving Underhill, LOC.)

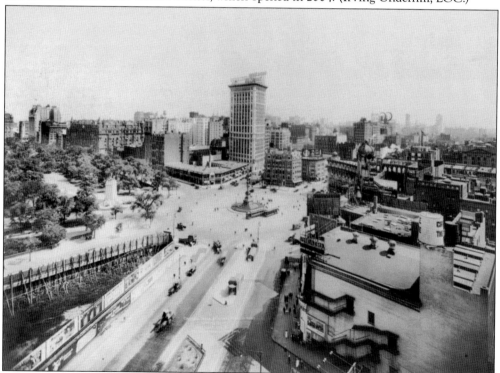

The signs at Columbus Circle, many as large and prominent as those in Times Square, were advertisements for Automobile Row, which was located on Broadway between Times Square and what is now Lincoln Center. United States Tires had a sign at the top of the tallest building in this 1913 photograph. (Irving Underhill, LOC.)

In 1913, William Randolph Hearst erected a monument at Central Park's Merchant's Gate to those who perished aboard the USS *Maine* in Havana Harbor. Among the many billboards in the background are those for Firestone Tires, Good Year, Selznick Pictures, and Camel cigarettes. (Irving Underhill, LOC.)

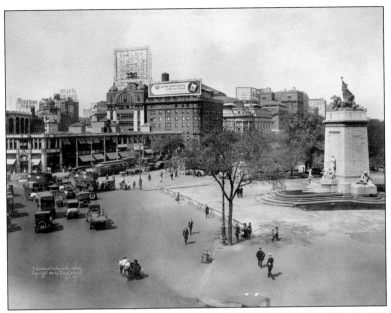

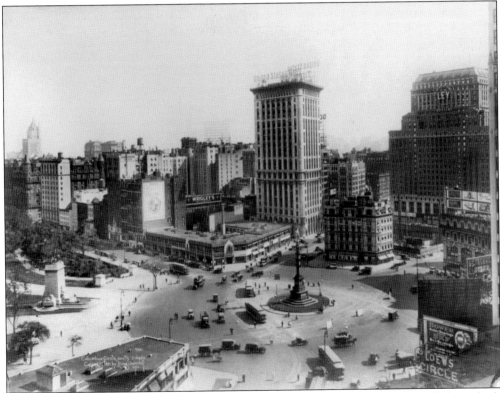

In 1921, Fisk Tire Company constructed the large, 25-story structure at Fifty-seventh Street, which was soon rivaled by the General Motors Building at Fifty-eighth Street. The GM Building was also known as the Colonnade Building because of the three-story ring of columns on its base. Both buildings still exist, but the Colonnade is now completely clad in glass, obscuring the original Corinthian column details at street level. (Irving Underhill, LOC.)

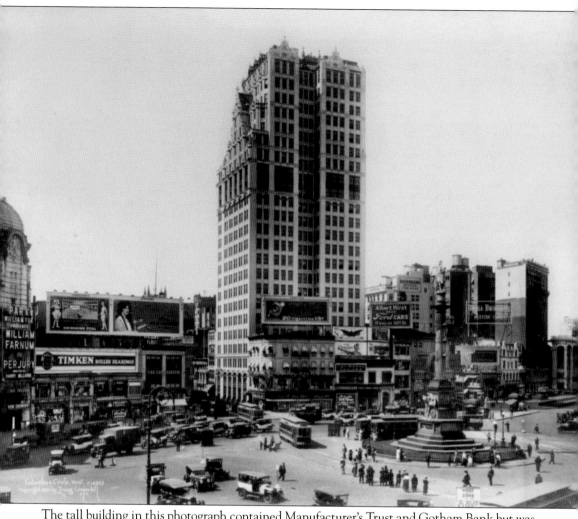

The tall building in this photograph contained Manufacturer's Trust and Gotham Bank but was later demolished to make way for the New York Coliseum. Fifty-ninth Street was then eliminated between Broadway and Columbus Avenue, a street pattern that continues to this day. (Irving Underhill, LOC.)

Five

Notable Events on Broadway

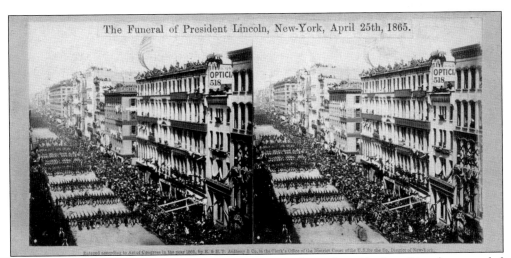

The Funeral of President Lincoln, New-York, April 25th, 1865.

On April 24, 1865, the funeral procession for assassinated president Abraham Lincoln proceeded down Broadway towards New York City Hall, where he lay in state overnight. The open casket was viewed by 120,000 people. A young Theodore Roosevelt is said to have watched the procession from a window on Broadway. (E.& H.T. Anthony & Co., LOC.)

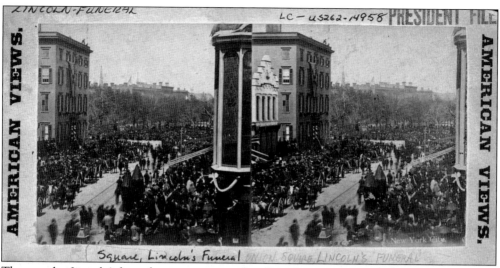

The next day, Lincoln's funeral cortege went north up Broadway to Union Square, where a ceremony took place. The procession would continue up Fifth Avenue to Thirty-fourth Street and end at the Hudson River Railway Depot, where the casket would get on a train to Albany. (LOC.)

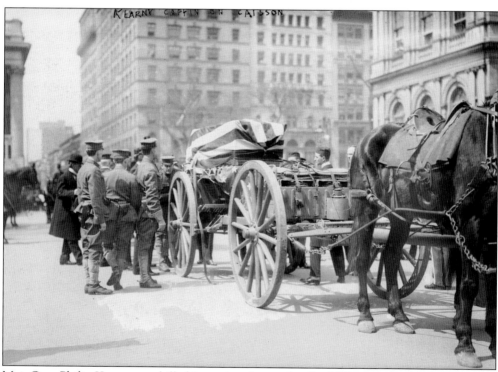

Maj. Gen. Philip Kearny was killed in action during the Civil War. His flag-draped coffin is shown here along Broadway, before he was buried in the Trinity Church cemetery. In 1912, Major Kearny's body was moved to Arlington Cemetery. (LOC.)

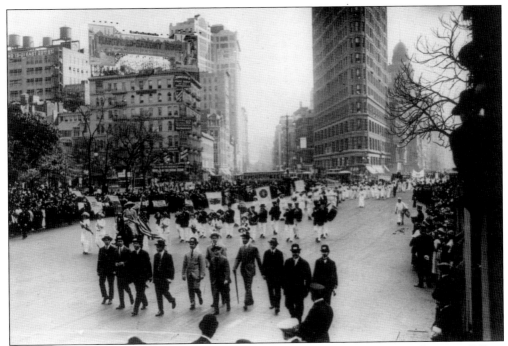

On March 3, 1913, a suffragette hike was organized from New York City to Washington, DC, to join the National American Woman Suffrage Parade. In this photograph, the parade has reached Madison Square, with the Flatiron Building in the background. (LOC.)

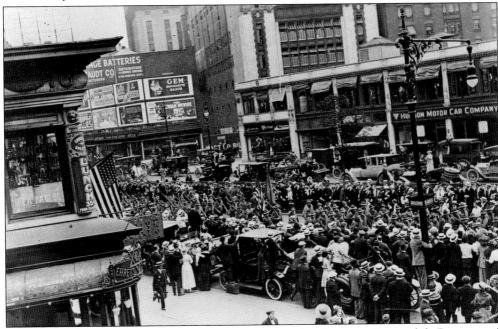

A parade of soldiers is seen here at Broadway and Sixty-first Street in Automobile Row around 1917. Appearing on this block is the Hudson Motor Company, Lozier Motor Company, and a dealership selling Apperson and Singer automobiles. On the eastern side of the block is a Chinese restaurant and tea parlor. (LOC.)

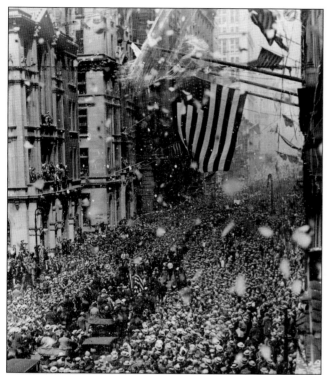

This image shows a ticker tape parade for American Olympic champion Gertrude Ederle in 1926, after she became the first woman to swim across the English Channel. She also beat the records of five men who swam the channel before her. (*New York World-Telegram and Sun*, LOC.)

Charles Lindbergh was also given a ticker tape parade in 1927 after his historic transatlantic solo flight in the monoplane *The Spirit of St. Louis*. The *New York Times* estimated that four million people were in the crowd to celebrate. (LOC.)

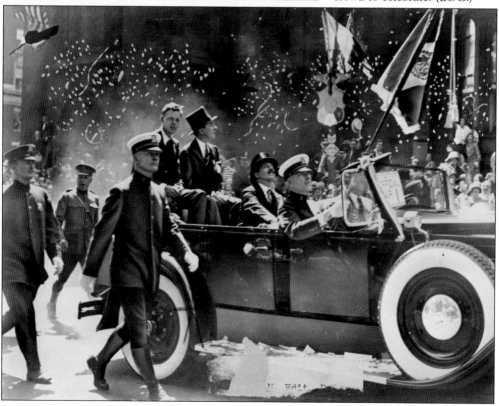

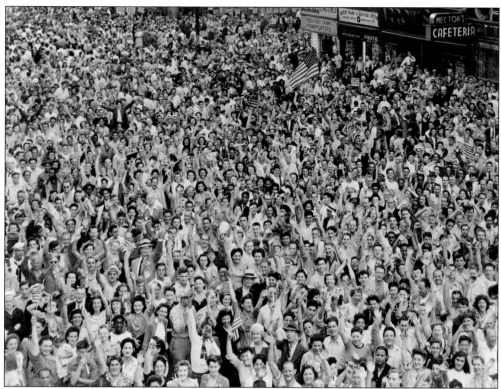

The crowds in Times Square on V-J Day on August 14, 1945, at the time of the announcement of the Japanese surrender were massive. The famous photographs of the sailor and the nurse were also taken on this day. (Dick DeMarsico, *New York World-Telegram and Sun* staff photograph, LOC.)

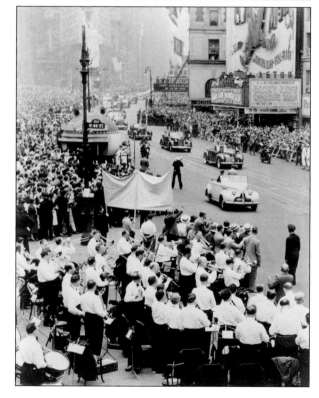

Five-star general Dwight D. Eisenhower is waving to the crowd at the head of a parade going up Broadway in Times Square next to the Astor Theatre. Eisenhower was the supreme commander of the Allied Forces in Europe during World War II. (Dick DeMarsico, *New York World-Telegram and Sun* Photograph Collection, LOC.)

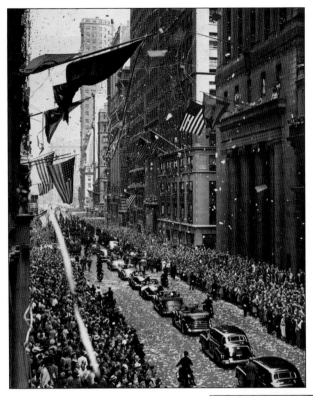

Gen. Jonathan M. Wainwright IV, commander of the Allied Forces in the Philippines during World War II, was given a motorcade from LaGuardia Field in 1945. The motorcade went up lower Broadway to New York City Hall, where he accepted an "honorary citizenship" in New York. Police estimated that at least three million people attended along the way. (Al Aumuller, *New York World-Telegram and Sun* Photograph Collection, LOC.)

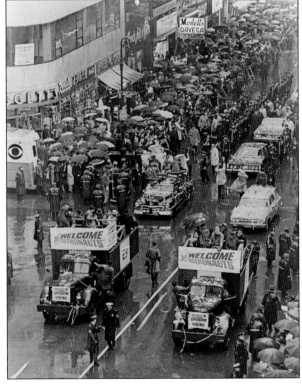

A ticker tape parade was held for astronauts John Young and Virgil Grissom, with United States vice president Hubert Humphrey in 1965. Grissom was the second American to fly in space. Young was the ninth person to walk on the moon. (Roger Higgins, *New York World-Telegram and Sun* Photograph Collection, LOC.)

Six

BROADWAY'S HISTORIC INSTITUTIONS

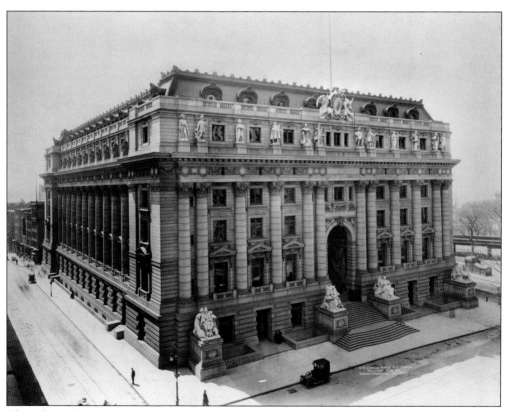

The Alexander Hamilton US Custom House is a Beaux-Arts structure by architect Cass Gilbert, who also designed the Woolworth Building. Located at Bowling Green on the site of the former Fort Amsterdam and Government House, it is now the National Museum of the American Indian. (Irving Underhill, LOC.)

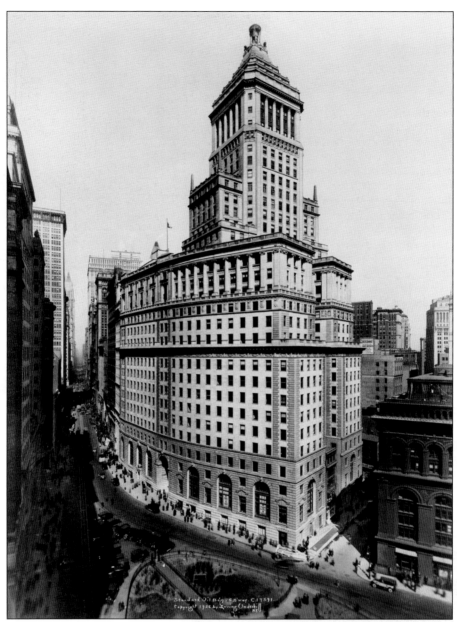

The Standard Oil Building, constructed for John D. Rockefeller's company, has had several iterations. The first structure was built from 1884 to 1885 on a design by Ebenezer L. Roberts and was only 10 stories. In 1895, Kimball and Thompson enlarged the structure, adding six stories and an extension on the north side of the plot. After World War I, the company purchased all the other buildings on the block and made preparations for another expansion. Thomas Hastings, of Carrère and Hastings, along with Shreve, Lamb & Blake, led the project, which lasted from 1920 to 1928. The setback structure is topped with a pyramid, much like the Cunard Building across the street, which was also designed by Hastings. At the top was a cauldron of kerosene that burned 24 hours a day, reminding onlookers about the nature of the business in the building. (The Rockefellers had initially been involved in kerosene.) The lower levels of the building are now schools with a gymnasium retrofitted inside. (Irving Underhill, LOC.)

Among those buried in the graveyard of Trinity Church are Alexander Hamilton, Robert Fulton, William Bradford, and Capt. James Lawrence, who uttered his famous last words "Don't give up the ship!" during the Battle of 1812. The interior of the church is in the Gothic Revival style with pointed arches and stained glass on both sides of the chapel, as well as above the altar. During the September 11th attacks in 2001, a sycamore tree at nearby St. Paul's Chapel was uprooted and later transformed by artist Steve Tobin into a sculpture, which is displayed just outside Trinity Church. (Right, American Studio, NY; below, Detroit Publishing Co., LOC.)

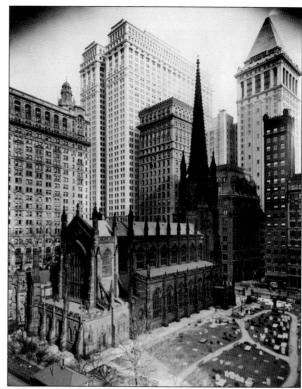

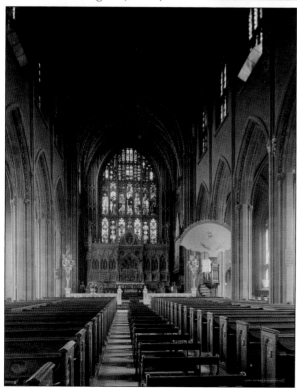

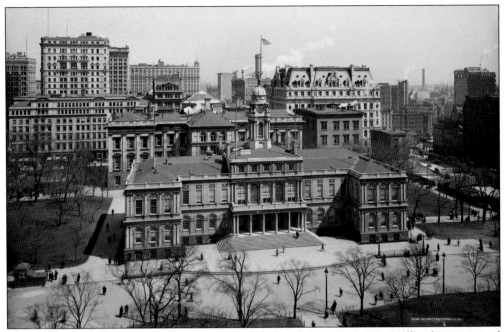

Though there were many motions to relocate or demolish New York City Hall, it has remained the seat of New York City government. The building melds French Renaissance influence with American Federal style, a manifestation of the two architects, Joseph François Magin of France and John McComb Jr., the first native-born New York City architect. (Detroit Publishing Co., LOC.)

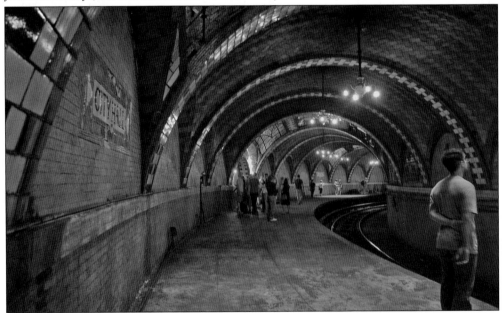

Under City Hall Park sits a decommissioned subway station. Designed by Heins and LaFarge, it was the southern terminus of the IRT subway line. It was the crown jewel of the system, which opened in 1904, with tile vaults by R. Guastavino & Company, arched supports, and panels of stained-glass skylights. The station was rendered obsolete due to its curved platform, which was too short for the trains in use today. (Michelle Young.)

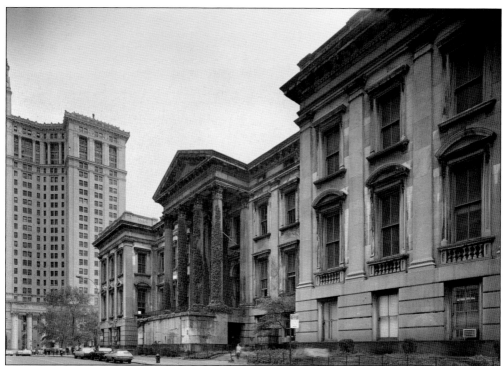

The Tweed Courthouse was completed in 1878 at a cost of more than $13 million, much of which was political graft. It was the first government building constructed after New York City Hall. The infamous William M. "Boss" Tweed was never able to make use of the grand, Victorian-style courthouse, however, because he was in and out of incarceration starting in 1873. He died in prison of pneumonia in 1878. The building is constructed of grey Massachusetts marble and is a national and city landmark. The interior features an octagonal rotunda that stretches the entire height of the building. (Both, LOC.)

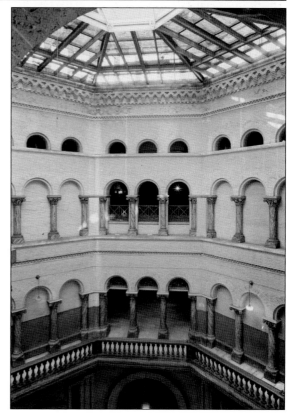

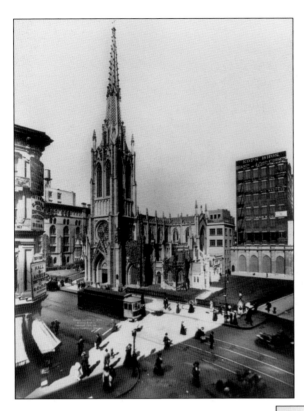

Grace Church is a landmarked Episcopal church on Broadway and Tenth Street designed by James Renwick Jr., who was also the architect of St. Patrick's Cathedral on Fifth Avenue. The front garden was designed by Vaux & Co., the firm of Central Park designer Calvert Vaux. (Irving Underhill, LOC.)

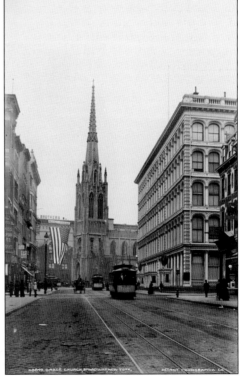

This photograph of Grace Church also includes the A.T. Stewart Dry Goods store (later Wanamaker's), one of the grandest shopping destinations in New York City at the time, with a central atrium and skylight. The A.T. Stewart store was also one of the first buildings in New York to use a cast-iron facade but was destroyed by a fire in 1956. It is now an apartment building. (Detroit Publishing Co., LOC.)

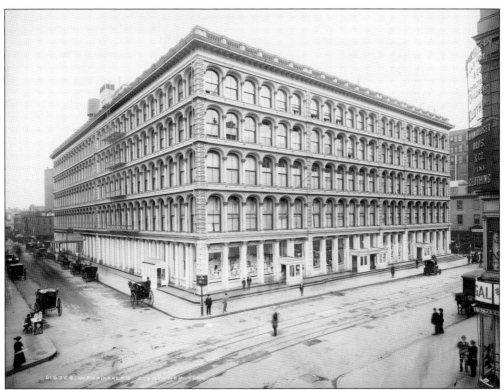

An annex built by D.H. Burnham & Co. made A.T. Stewart's the largest department store in the world by 1870, with a magnificent bridge connecting to the main store. The annex still stands today as an office building. (Detroit Publishing Co., LOC.)

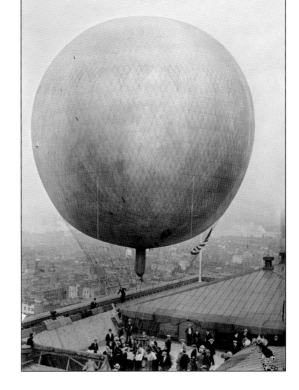

In 1911, Wanamaker's launched a hydrogen balloon off the roof of the annex building aimed for the store's flagship location in Philadelphia. It ended up going north instead, crash landing in Nyack, New York, but the balloon stunt still gave the store the publicity it wanted. (LOC.)

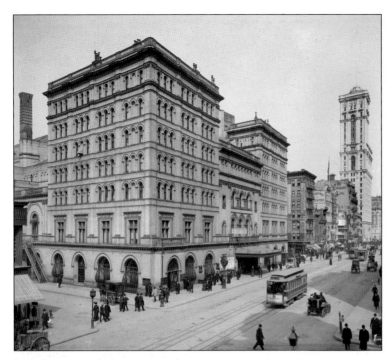

The original Metropolitan Opera House opened in 1883 on Thirty-ninth Street and Broadway, closer to the city's emerging mansion district. Its arrival spurred the development of the theater district that centered around Long Acre Square. The opera house was designed by architect J. Cleaveland Cady. (Detroit Publishing Co., LOC.)

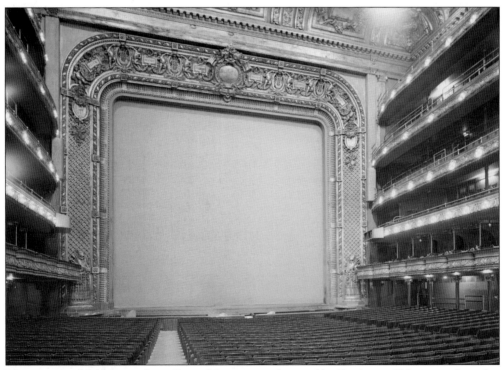

The interior of the Metropolitan Opera House was redesigned by Carrère and Hastings after a fire in 1892. The gilded auditorium had a proscenium arch inscribed with the names of six classical composers. (Jack E. Boucher, LOC.)

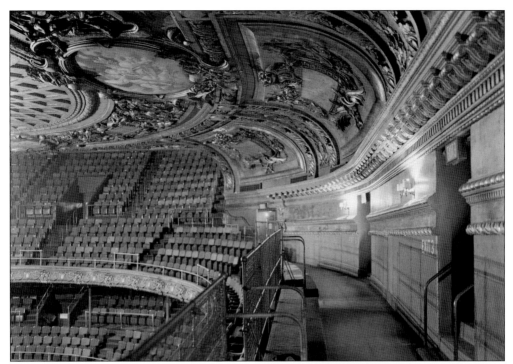

When the Metropolitan Opera decided to relocate to Lincoln Center in the 1960s, the future of the existing building was called into question. Ironically, the Metropolitan Opera Association supported its demolition, fearing competition if another opera company took over the space. Due to questions over the integrity of the architecture, the building was not landmarked. It was demolished in 1967 and replaced with an office skyscraper. (Jack E. Boucher, LOC.)

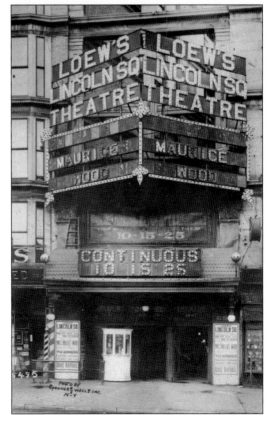

Lincoln Center was built atop the once lively neighborhood of San Juan Hill, targeted by Robert Moses for urban renewal. Once a destination for live jazz, it was also the location of one of Marcus Loew's first Manhattan theaters. Located on Sixty-sixth Street and Broadway, Loew's Lincoln Square Theatre opened in 1906. It later became a television studio but was demolished to make way for the Juilliard School and Alice Tully Hall, both of which opened in 1969. (NYPL.)

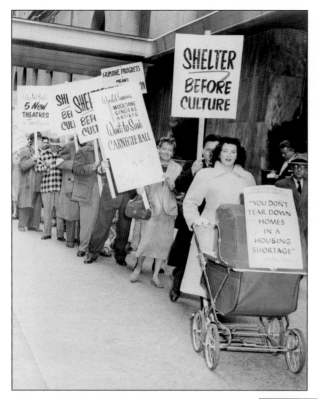

The demolition of San Juan Hill also impacted the Lincoln Square neighborhood. Residents protested in a picket line with signs proclaiming "Shelter before culture," "You don't tear down homes in a housing shortage," and more. (Phil Stanziola, *New York World-Telegram and Sun* Photograph Collection, LOC.)

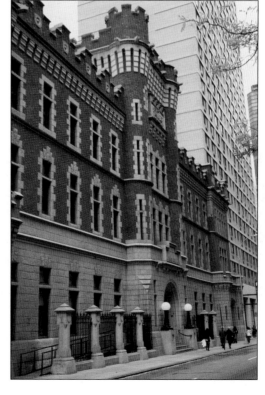

The castle-like First Battery Armory of the New York National Guard on Sixty-sixth Street was built in 1901 and now serves as studios for the ABC network. The First Battery had a predominantly German-American membership. The 102nd Medical Batallion used the armory from 1913 to 1973. (Augustin Pasquet.)

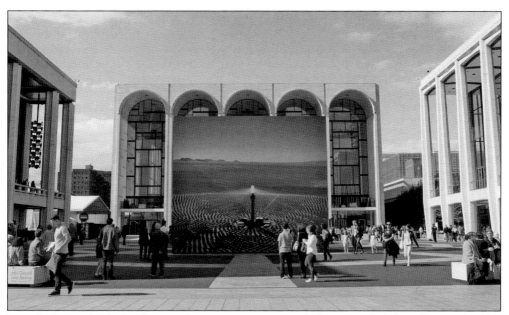

Lincoln Center for the Performing Arts was an initiative of John D. Rockefeller, who raised half of the $184 million to build the arts center. The Metropolitan Opera and the New York Philharmonic were both looking for new homes in the 1960s and relocated here. Fordham University, New York City Ballet, City Opera, and the Juilliard School followed. (Augustin Pasquet.)

In 2012, a major redesign of Lincoln Center took place, led by architecture firms Diller Scofidio + Renfro, FXFowle Architects, and Beyer Blinder Belle, modernizing the complex and improving the pedestrian experience at the arts complex. A large elevated plaza was removed over Sixty-fifth Street. Alice Tully Hall and the Juilliard School received new entrances and a new building was constructed for the Film Society of Lincoln Center. (Augustin Pasquet.)

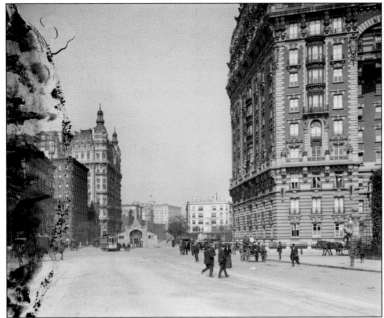

Some of the great early-20th-century apartments begin on Broadway after Lincoln Center. In this view from Seventieth Street, the Ansonia on Seventy-third Street is in view, along with the Dorilton, built in the Beaux-Arts style from 1900 to 1902 on Seventy-first Street. (Detroit Publishing Co., LOC.)

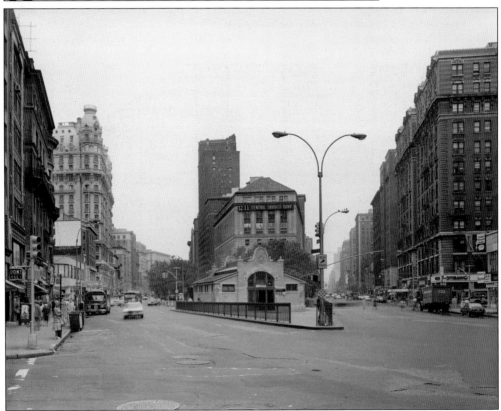

The Seventy-second Street subway station features one of the original fare control stations designed for the New York City subway by Heins & LaFarge in 1904. Details include wrought iron work, ceramic signage, and wall mosaics in the station. (LOC.)

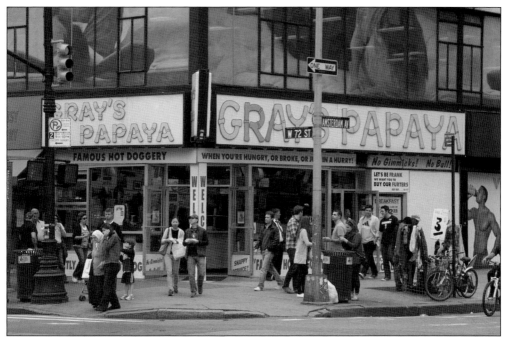

Always fun and often political, Upper West Side staple Gray's Papaya was founded in 1973, offering inexpensive hot dogs and juice drinks 24 hours a day. This original location at Seventy-second Street is the last of the joints left. (Augustin Pasquet.)

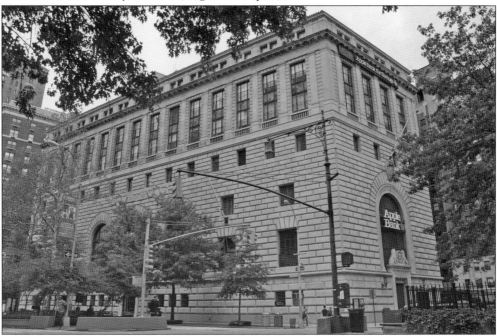

The Florentine palazzo–inspired Central Savings Bank at Seventy-third Street and Broadway is a landmarked beauty from 1928 that was designed by York & Sawyer. The interior has a vaulted ceiling, terrazzo floors, and glass-paneled doors. Long operated by Apple Bank, the building's upper floors were converted into condos in 2007. (Augustin Pasquet.)

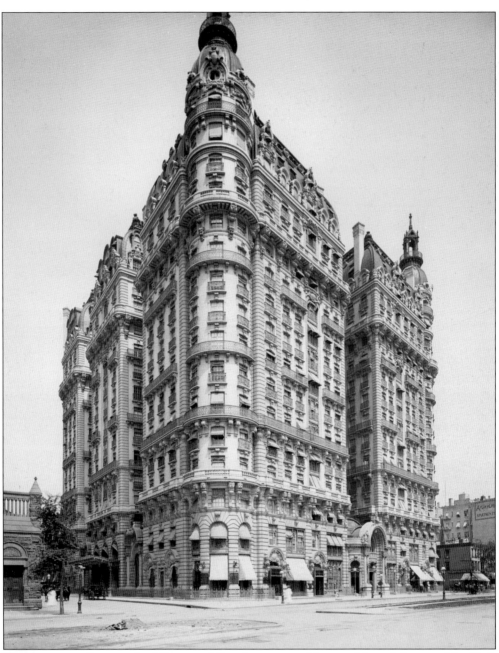

The Ansonia at Seventy-third Street and Broadway is arguably one of first of the great New York City apartment buildings and one of the most beloved, particularly among architecture critics. Built from 1899 to 1904 on the site of the former New York Orphan Asylum, the building was hailed by the Landmarks Preservation Commission as a "joyous exuberance profiled against the sky." In addition to the elegant details of the interior and exterior architecture, the building had its own art curator. Pneumatic tubes whisked messages through the walls of the Ansonia. Situated on the bohemian Upper West Side, the Ansonia had a rather scandalous and off-beat reputation. It was here in 1919 that the fateful meeting to fix the World Series took place, which was bankrolled by mobster Arnold Rothstein. (Detroit Publishing Co., LOC.)

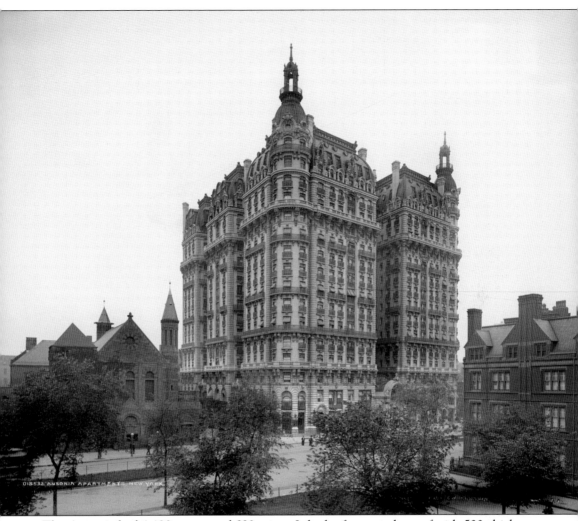

The Ansonia had 1,400 rooms and 320 suites. It had a farm on the roof with 500 chickens, ducks, goats, and a small bear. The basement contained what was the world's largest indoor pool at the time; it later operated as a gay bathhouse and swingers club. For much of its active life, the Ansonia operated illegally, lacking a certificate of occupancy from the city. After decades of near abandonment and decay, a group of investors bought the building in 1978 and spent $21 million to get the place up to code. Notable residents of the Ansonia have included Babe Ruth, Theodore Dreiser, Arturo Toscanini, Igor Stravinsky, Florenz Ziegfeld, Angelina Jolie, and Natalie Portman. (Detroit Publishing Co., LOC.)

The Level Club on Seventy-third Street was built in 1925 as a Masonic club and hotel at a cost of over $2 million. The 16-story building was modeled after Solomon's Temple in Jerusalem and had 225 rooms, a swimming pool, ballroom, Turkish bath, gymnasium, handball courts, billiard rooms, auditorium, dining room, and a library. After changing hands, it was converted into condos in 1984 and had its interiors mostly gutted. (Michelle Young.)

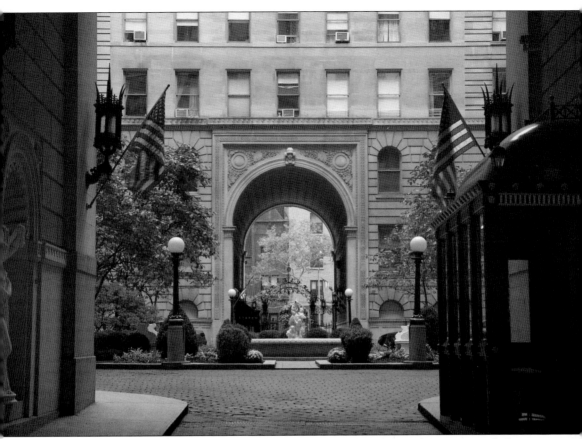

The Apthorp, a stylish apartment complex between Seventy-eighth and Seventy-ninth Streets on Broadway, was built by the Astors as speculative real estate after the IRT subway line opened. The 12-story limestone building was designed in the style of an Italian Renaissance palazzo with an interior courtyard, fountains, and Beaux-Arts archway entrances. Its amenities and services allegedly surpassed those of the Ansonia. (Augustin Pasquet.)

The Upper West Side institution known as Zabar's began as a 22-foot-wide store on Eightieth Street and Broadway in 1934, selling quality groceries at reasonable prices. Still a family business, Zabar's now spans the entire block. (Augustin Pasquet.)

The RKO Eighty-first Street Theater was a vaudeville theater designed by Thomas Lamb in 1913. CBS converted it into the first major color television studio in New York in 1954. In 1986, the theater interior was demolished to make way for the entrance to an apartment building. Despite the retail on the first and second floors, evidence of the former theater can still be seen on the facade. (Augustin Pasquet.)

The Belnord apartment on Eighty-sixth Street is another Astor family real estate endeavor, similar to the Apthorp, which was built a year earlier in 1908. The Belnord has a limestone exterior and a beautiful interior courtyard with arched entryways. (Julia Vitullo-Martin.)

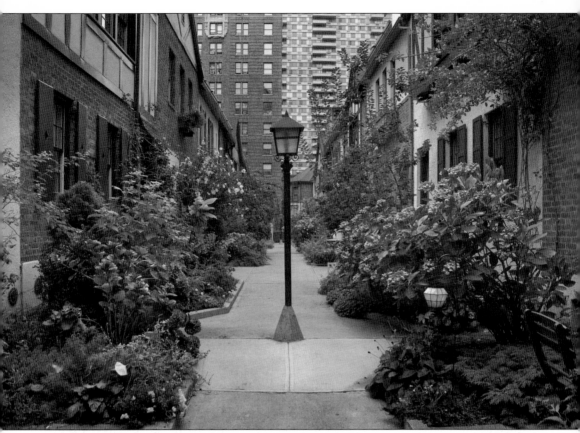

Pomander Walk remains one of the city's most elusive hidden gems. This quaint English-style street between Broadway and West End Avenue on Ninety-fourth and Ninety-fifth Streets is accessible only to residents via a locked gate. The Tudor-style development was the venture of Thomas Healy, an Irish immigrant and hotelier in New York. There are just 28 houses, each with a small garden in front. (Michelle Young.)

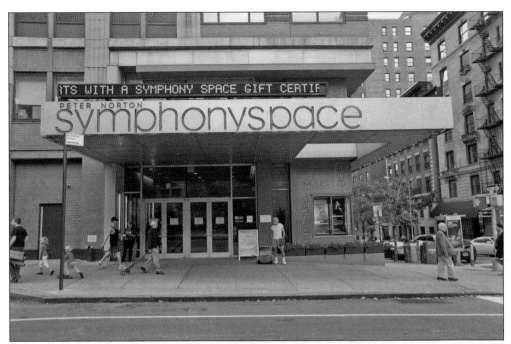

A beloved neighborhood performing arts center, Symphony Space was part of the long-term revitalization of the Upper West Side, an initiative spurred by the neighborhood's residents. Surviving a slew of real estate maneuvers, Symphony Space sold its air rights and now sits below an apartment building, still offering unique programming. (Augustin Pasquet.)

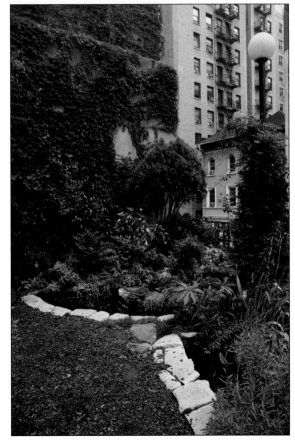

Just off Broadway on Ninety-seventh Street is Lotus Garden, a private elevated community garden that opens to the public on Sundays. It was one of the first green roofs in the city, created as a real estate concession by the high-rise apartment that shares the plot of land. With a fish pond, dense vegetation, and a living wall, Lotus Garden is a pleasant escape above the street. (Michelle Young.)

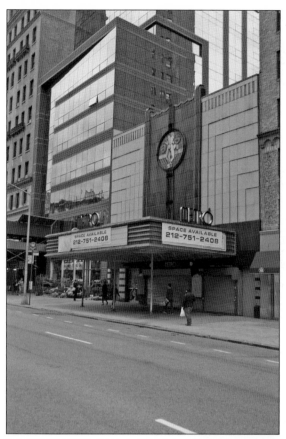

The Art Deco Metro Theater was built from 1932 to 1933. It has sat empty for a decade, with the interior gutted in the interim. The theater still awaits a new tenant after Alamo Drafthouse cinema backed out of a deal in 2013. (Augustin Pasquet.)

At 100th Street and Broadway is the rare remnant of a wood-frame building, with the Metro Diner on the first floor. The AIA Guide to New York City calls it a "holdout from the West Side's frontier days." (Augustin Pasquet.)

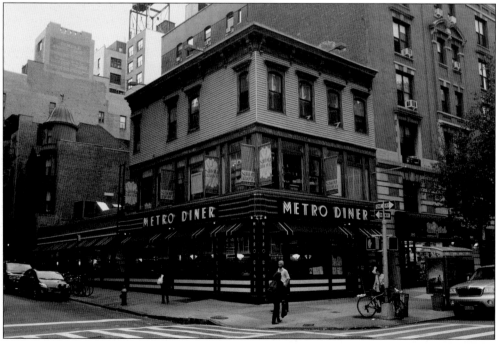

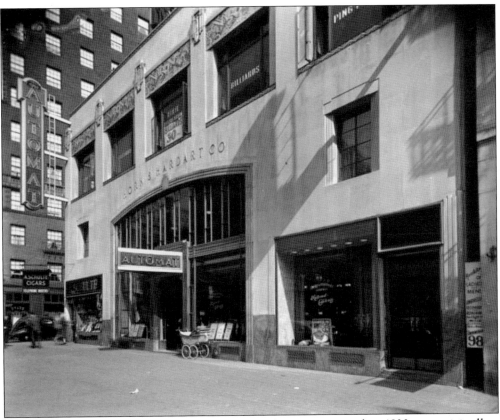

This Art Deco building at 104th Street and Broadway, constructed in 1930, was originally a location for the well-known automat chain Horn & Hardart. Over the years, the building has been a New York Public Library, a pizza store, coffee shop, supermarket, and is now a Rite Aid Pharmacy. (NYPL.)

Columbia University was built on the former Bloomingdale Asylum, a public hospital petitioned for by the doctors at King's College. The 26-acre bucolic institution extended over to where the Cathedral of St. John the Divine is today. Columbia University moved to this location in 1897, its campus designed by McKim, Mead, and White. (Detroit Publishing Company, LOC.)

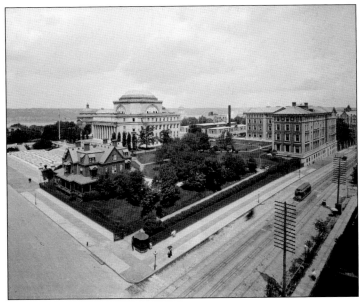

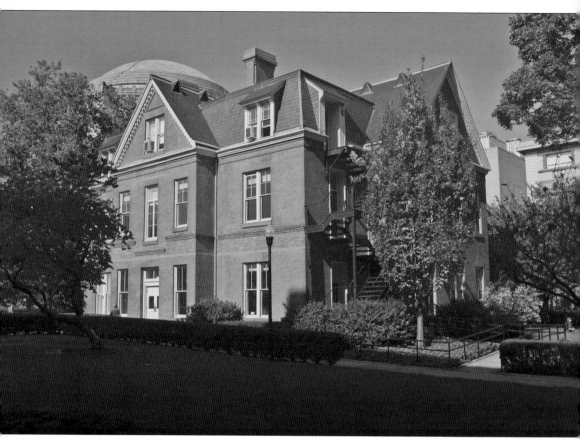

Of the original buildings from the Bloomingdale Asylum, only Buell Hall remains. Built in an elevated architectural style to house wealthy gentlemen suffering from mental affliction, it was moved to its current spot from across the campus. Today, it houses the Maison Française at Columbia University. (Michelle Young.)

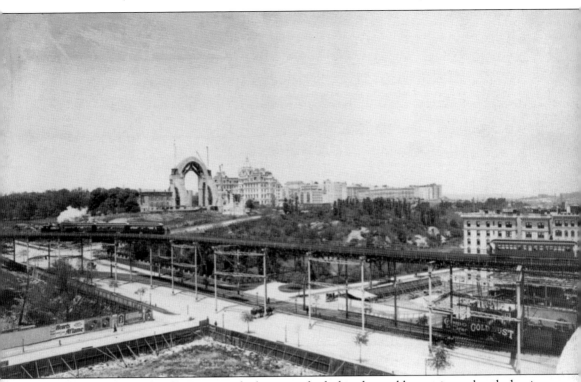

The Church of St. John the Divine is the largest cathedral in the world, meaning a church that is also the seat of a bishop. Built in the true Gothic method, the cathedral's construction began in 1892, but the structure remains unfinished. This image from 1902 is taken from the east showing Morningside Park and the elevated railway. (Irving Underhill, LOC.)

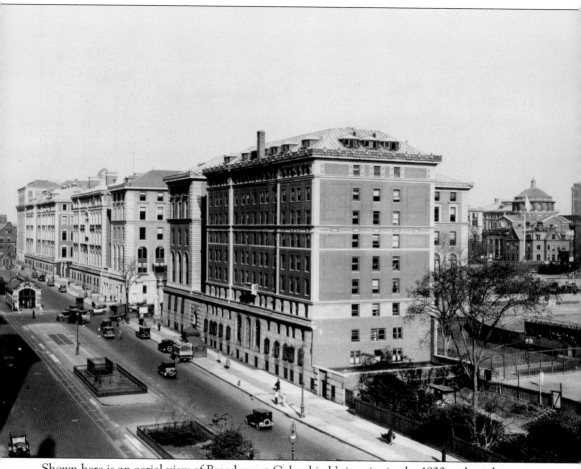

Shown here is an aerial view of Broadway at Columbia University in the 1920s, when the main thoroughfare through the campus was still open to automobiles. Note the original fare control house at the 116th Street entrance to the subway, a structure that no longer exists. (LOC.)

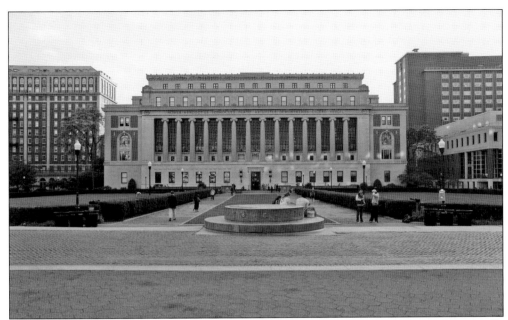

Completed in 1934, Butler Library is the largest of Columbia University's libraries. Originally known as South Hall, it was renamed in 1946 in honor of Nicholas Murray Butler, the school's president from 1902 to 1945. On the sixth floor of Butler Library is the mantel in front of which Edgar Allan Poe wrote the famous poem "The Raven." (Michelle Young.)

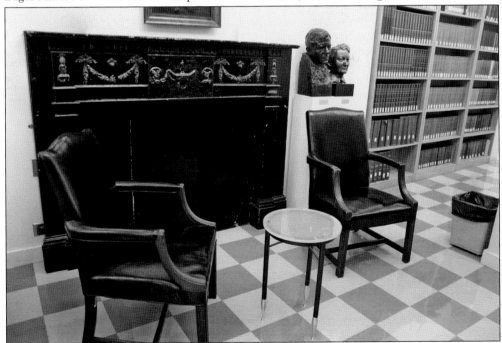

The mantel was originally located in the Brennan farmhouse around Eighty-fourth Street and Broadway, where Poe had lived. Unaccounted for decades, it was rediscovered by Benjamin Waldman, history editor for *Untapped Cities*. The school later moved the mantel out from a storage room and into public view in the Columbia University Archives. (Michelle Young.)

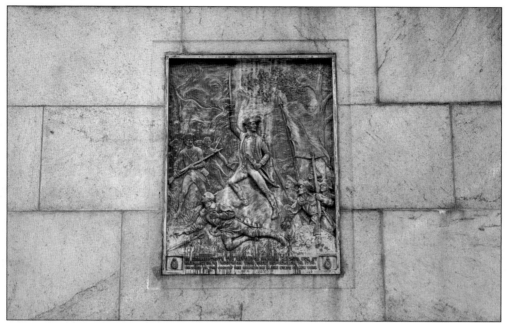

A plaque on the Mathematics Building at Columbia University commemorates the Battle of Harlem Heights, a morale turning point in the American Revolution. The majority of the military action occurred between 106th Street and 120th Street and between Broadway and Riverside Drive. (Michelle Young.)

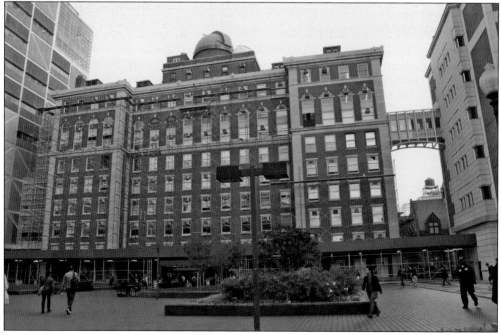

Research for the Manhattan Project was conducted in Schermerhorn Hall and Pupin Hall (shown) on Broadway and 120th Street. The basement of Pupin Hall hosted a cyclotron, a particle accelerator. In 1939, Columbia scientists replicated a German experiment that proved the possibility of nuclear fission. (Michelle Young.)

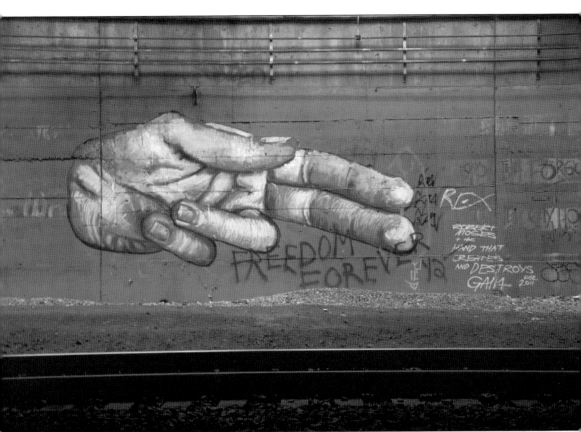

In the 1930s, Robert Moses spearheaded the Westside Improvement Project that covered the New York Central Railroad tracks. The northern entrance of the tunnel begins at 125th Street, east of Broadway. The Amtrak tunnel is popularly known as the Freedom Tunnel, named after the street artist Chris Pape, also known as "Freedom," who produced numerous large-scale murals inside the tunnel. Above the Freedom Tunnel sits Riverside Park. (Michelle Young.)

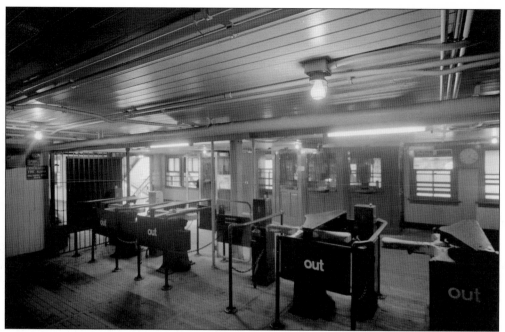

The elevated subway station at 125th Street was built as part of the original IRT subway line and is the only station on the Manhattan Valley Viaduct. It is listed in the National Register of Historic Places. This photograph from the 1970s shows the station with its former wooden floors and turnstiles. (LOC.)

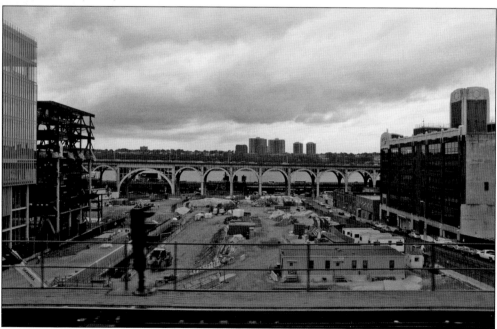

The area around the Henry Hudson Viaduct has become more developed over the last decade, in anticipation of the expansion of Columbia University to Manhattanville, a contested plan enabled by eminent domain. Neither the current state of the neighborhood nor its future bears much resemblance to the bucolic area as it was first settled. (Michelle Young.)

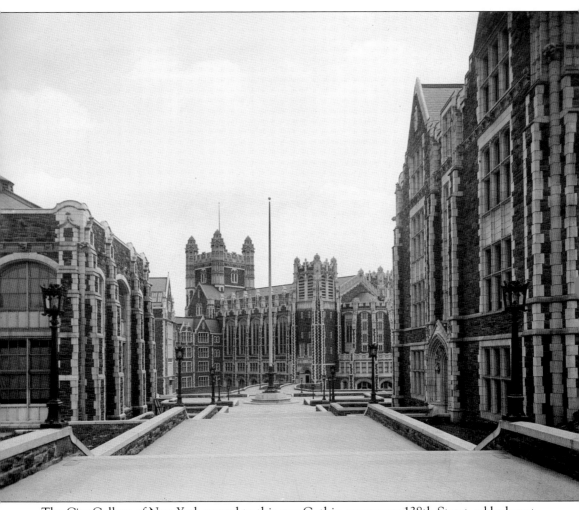

The City College of New York moved to this neo-Gothic campus on 138th Street, a block east of Broadway, in 1907. The buildings are constructed from the Manhattan schist removed during the excavation of the subway tunnels. (Detroit Publishing Co., LOC.)

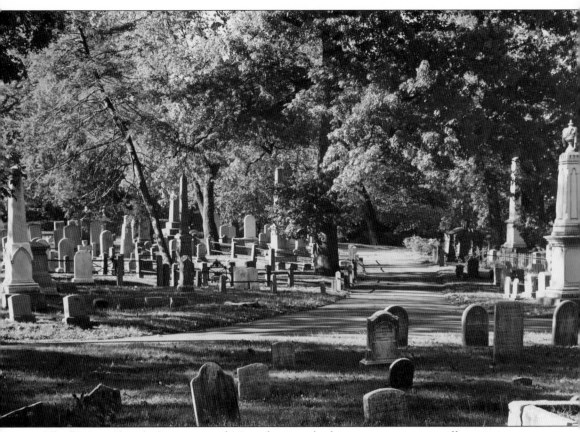

The Trinity Church Cemetery and Mausoleum is the last active cemetery still accepting new residents in the borough of Manhattan. The cemetery was founded on the former estate of John James Audubon between 153rd Street and 155th Street. Those buried in the cemetery include Audubon, former New York City mayor Edward I. Koch, many in the Astor family, Ralph Waldo Ellison, Alfred Tennyson Dickens, and actor Jerry Orbach. (Bhushan Mondkar.)

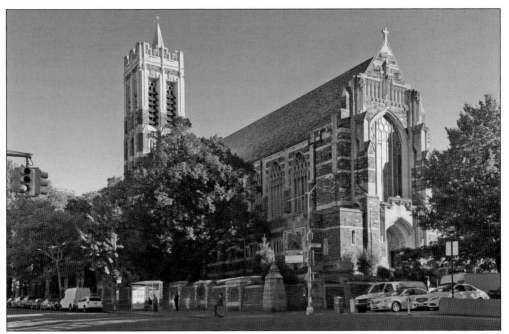

When the Church of the Intercession was completed in 1913, it was the first columbarium (a location to hold cinerary urns) in America. Today, the large underground crypt has hosted regular jazz concerts, a revival of *Jesus Christ Superstar*, and Prohibition-style cocktail parties. (Bhushan Mondkar.)

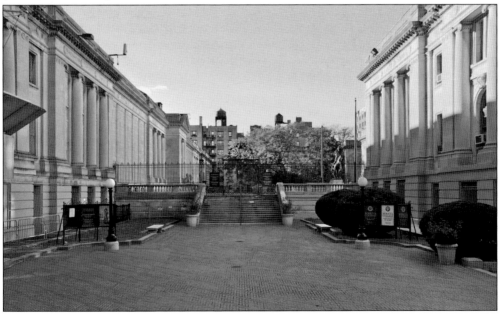

Audubon Terrace in Washington Heights is home to the Hispanic Society of America and the American Academy of Arts and Letters. The Hispanic Society of America holds the largest collection of 19th-century Spanish art outside of Spain, including works by Francisco Goya, El Greco, and Diego Velázquez. As a landmarked historic district, Audubon Terrace is the only museum complex designed as a single unit in Manhattan. (Bhushan Mondkar.)

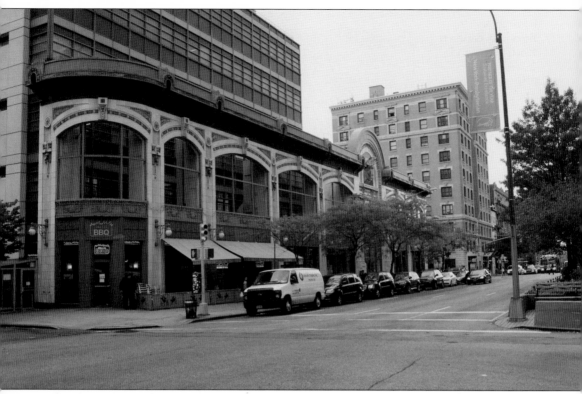

The infamous Audubon Ballroom at 166th Street is where Malcolm X was assassinated in 1965. It was originally built as the William Fox Audubon Theater in 1912 and designed by Thomas Lamb. Today, it is owned by Columbia University and contains the Malcolm X and Dr. Betty Shabazz Memorial and Education Center. (Michelle Young.)

Located on Broadway between 165th Street and 168th Street, Columbia University Medical Center (formerly New York Presbyterian Hospital) was the first institution to merge a medical school with a significant hospital. It remains today a relevant force in medical research and treatment. (Irving Underhill, LOC.)

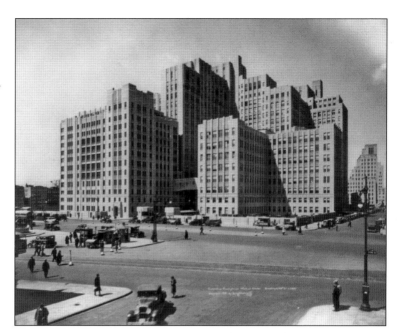

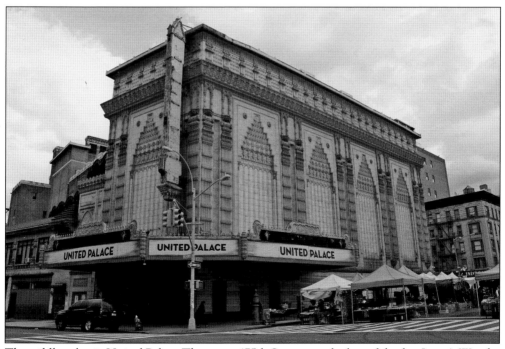

The wildly eclectic United Palace Theater at 175th Street was the last of the five Loew's Wonder Theaters in New York City. Designed by Thomas Lamb, the theater could seat nearly 3,300 people. In 1969, it was saved from possible demolition by the Reverend Frederick J. Eikerenkoetter II, who turned the theater into a church. (Michelle Young.)

Fort Tryon Park, which stretches from the Hudson River to Broadway, is named after Sir William Tryon, the last English governor of New York. The land was once the estate of Cornelius King Garrison Billings, a Gilded Age millionaire who built a 21-room mansion overlooking the Hudson River. The mansion was sold to John D. Rockefeller, who intended to build a park. It later burned to the ground. (Jane Hu.)

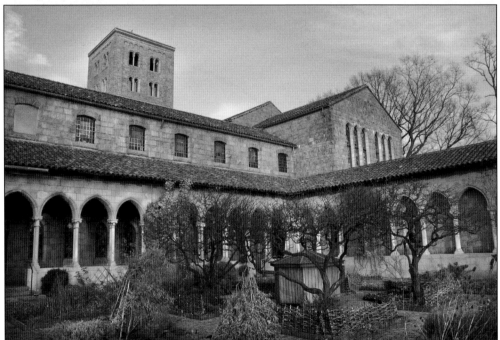

Fort Tryon Park also contains The Cloisters, a branch of the Metropolitan Museum of Art that focused on medieval European art. The structure itself, in the style of a monastery, is made from a combination of various medieval buildings acquired from Europe. (Jane Hu.)

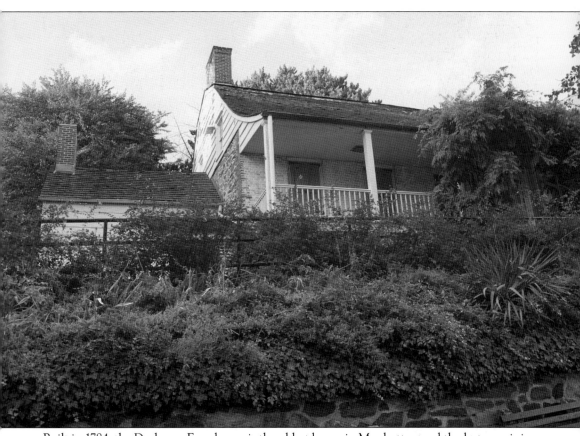

Built in 1784, the Dyckman Farmhouse is the oldest house in Manhattan and the last remaining farmhouse in the borough. Situated at 204th Street and Broadway amidst the urban fabric of Inwood, the Dutch-era house now operates as a museum. (Michelle Young.)

Isham Park sits right alongside Broadway and was built on a former dump and possible Native American burial ground. While it serves as a welcome respite from busy Broadway, the real gem is Bruce's Garden, a beautiful garden honoring fallen 9/11 responder Bruce Reynolds, who grew up tending the plot of land as a teenager. (Michelle Young.)

The 35-foot Seward-Drake Arch at 216th Street was once the grand entranceway to the hilltop estate of the Drake family and was built with marble quarried from a location along Broadway. The mansion was demolished in 1938 and the land subdivided, but the arch has remained. It has deteriorated over the years and is now graffiti-ridden and mostly forgotten. (Michelle Young.)

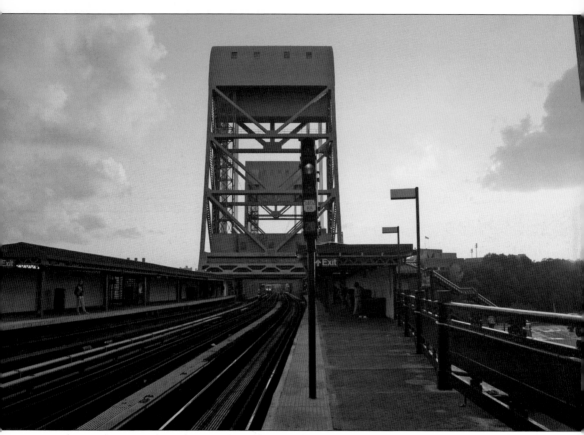

At the northern tip of Manhattan, the Broadway Bridge is the third bridge to span this portion of the Harlem River Ship Canal. Prior to the construction of the canal, the Marble Hill neighborhood (now on the Bronx side) was part of the island of Manhattan. (Michelle Young.)

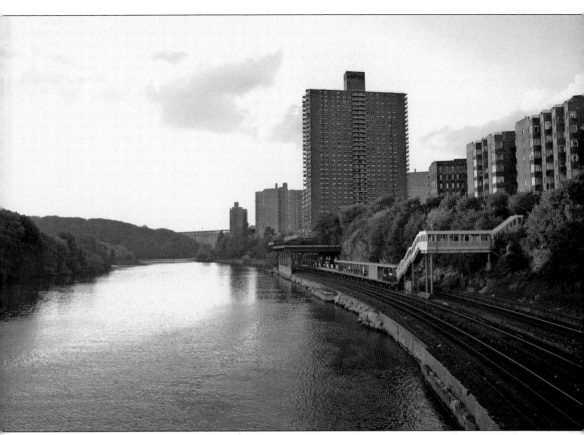

Marble Hill remained an island until 1914, when the northern portion of the Harlem River was filled in. Though Marble Hill is now connected to the Bronx, it remains politically part of the Manhattan district. Its name is derived from the Inwood marble quarried there for New York City's federal buildings in the 18th century. (Michelle Young.)

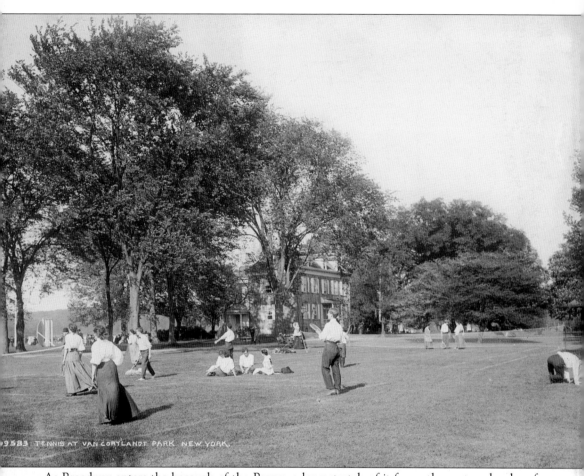

9583 TENNIS AT VAN CORTLANDT PARK NEW YORK.

As Broadway enters the borough of the Bronx, a long stretch of it forms the eastern border of Van Cortlandt Park, the fourth-largest park in New York City. The land was originally part of the Philipse family estate. (Detroit Publishing Co., LOC.)

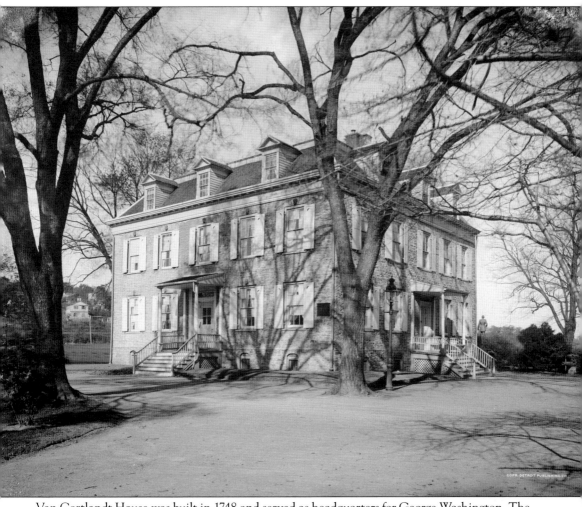

Van Cortlandt House was built in 1748 and served as headquarters for George Washington. The family burial vault was the hideaway for the city's municipal records during the war. The house was New York City's first historical house museum. (Detroit Publishing Co., LOC.)

BIBLIOGRAPHY

Alexiou, Alice Sparberg. *The Flatiron: The New York Landmark and the Incomparable City That Arose With It*. New York: St. Martin's Press, 2010.

Brown, Henry Collis. *Glimpses of Old New York*. New York: Lent & Graff, 1916.

Cohen, Paul E. and Robert T. Augustyn. *Manhattan in Maps: 1527–2014*. New York: Rizzoli International Publications, 2014.

Gray, Christopher. "Streetscapes column." *New York Times*. Various dates.

Jenkins, Stephen. *The Greatest Street in the World*. New York: Knickerbocker Press, 1911.

Kunz, George Frederick. *Catskills Aqueduct Celebration*. New York: The Mayor's Catskill Aqueduct Celebration Committee, 1917.

Lockwood, Charles. *Manhattan Moves Uptown: An Illustrated History*. Boston: Houghton Mifflin, 1976.

"Plan 22-Story Hotel for Times Square." *New York Times*. August 9, 1911.

Reiss, Marcia. *Lost New York*. London: Pavilion Books, 2011.

Stern, William J. "The Unexpected Lessons of Times Square's Comeback." *City Journal*. Autumn 1999.

University Lectures Delivered by Members of the Faculty in the Free Public Lecture Course 1916–1917. Vol IV. Philadelphia: University of Pennsylvania, 1917.

White, Norval and Elliot Willensky. *AIA Guide to New York City Fourth Edition*. New York: Three Rivers Press, 2000.

Jackson, Kenneth T., ed. *The Encyclopedia of New York City Second Edition*. New Haven: Yale University Press, 2010.

ABOUT UNTAPPED CITIES

Untapped Cities is a publication about urban discovery and exploration headquartered in New York City that was founded in 2009 by Michelle Young. The online magazine enables residents to rediscover their city through uncovering the unseen—whether hidden, unnoticed, or lost—and how such pieces of history inform city life now and in the future. *Untapped Cities* is a community of over 400 contributors worldwide. Visit the website at untappedcities.com.

DISCOVER THOUSANDS OF LOCAL HISTORY BOOKS
FEATURING MILLIONS OF VINTAGE IMAGES

Arcadia Publishing, the leading local history publisher in the United States, is committed to making history accessible and meaningful through publishing books that celebrate and preserve the heritage of America's people and places.

Find more books like this at
www.arcadiapublishing.com

Search for your hometown history, your old stomping grounds, and even your favorite sports team.

Consistent with our mission to preserve history on a local level, this book was printed in South Carolina on American-made paper and manufactured entirely in the United States. Products carrying the accredited Forest Stewardship Council (FSC) label are printed on 100 percent FSC-certified paper.

MADE IN THE

USA